BFI FILM CLASSICS

· ·

Rob White
SERIES EDITOR

Colin MacCabe and David Meeker
SERIES CONSULTANTS

Cinema is a fragile medium. Many of the great classic films of the past now exist, if at all, in damaged or incomplete prints. Concerned about the deterioration in the physical state of our film heritage, the National Film and Television Archive, a Division of the British Film Institute, has compiled a list of 360 key films in the history of the cinema. The long-term goal of the Archive is to build a collection of perfect showprints of these films, which will then be screened regularly at the Museum of the Moving Image in London in a year-round repertory.

BFI Film Classics is a series of books commissioned to stand alongside these titles. Authors, including film critics and scholars, film-makers, novelists, historians and those distinguished in the arts, have been invited to write on a film of their choice, drawn from the Archive's list. Each volume presents the author's own insights into the chosen film, together with a brief production history and a detailed filmography, notes and bibliography. The numerous illustrations have been specially made from the Archive's own prints.

With new titles published each year, the BFI Film Classics series will rapidly grow into an authoritative and highly readable guide to the great films of world cinema.

Could scarcely be improved upon . . . informative, intelligent, jargon-free companions.
The Observer

Cannily but elegantly packaged BFI Classics will make for a neat addition to the most discerning shelves.
New Statesman & Society

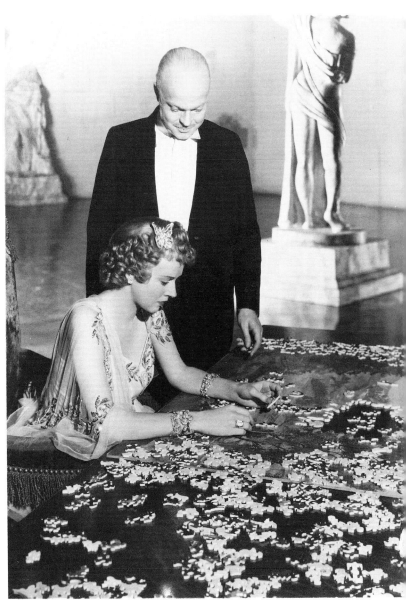
At home in Xanadu

BFI FILM CLASSICS

CITIZEN KANE

·····················

Laura Mulvey

A BFI book published by Palgrave Macmillan

First published in 1992 by the
BRITISH FILM INSTITUTE
21 Stephen Street, London, W1P 2LN

Reprinted 1994, 1997, 2008

British Library Cataloguing in Publication Data

Mulvey, Laura
Citizen Kane
1. Title
791.4372

ISBN 978-0-85170-339-8

Designed by
Andrew Barron and Collis Clements Associates

Typesetting by
Fakenham Photosetting Limited, Norfolk

Printed in Great Britain by
Norwich Colour Print

CONTENTS

For Faysal Abdullah
Solidarity and cinema

ACKNOWLEDGMENTS

I have been unable in this short text to give adequate acknowledgment of all the extraordinary amount of film theory and criticism that *Citizen Kane* has generated over its first half century. This body of work bears witness both to the power of such an enigmatic text to stimulate enquiry and to the increasing sophistication and research with which these enquiries are carried out. This essay is a partial and personal view, and not an assessment of the critical field. I would like to thank Ernie Eban for help with books and comments, Ed Buscombe for patience and editorial help and Tise Vahimagi for help with the stills. Production stills also came from the Museum of Modern Art, New York. I would also like to thank Ann Banfield, Sylvia Mulvey, Michael Rogin, Jacqueline Rose, Chad Wollen and Peter Wollen for encouragement and discussions about this essay, and particularly Paul Arthur for his insights in conversation and for reading and commenting on the text.

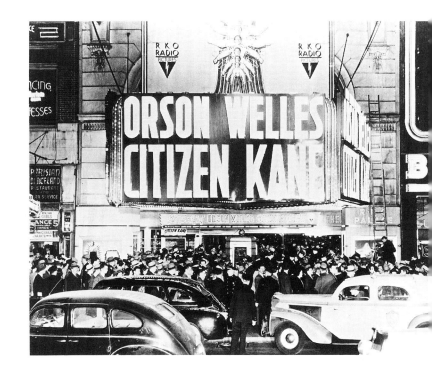

'CITIZEN KANE'
. .

Borges described *Citizen Kane* as a labyrinth without a centre.[1] And its elusiveness is one of the qualities that makes it infinitely re-viewable, re-debatable. So, as though in a quest for a cinematic Holy Grail or philosopher's stone, each generation of moviegoers, video watchers, film critics, film theorists, sets out in search of the bit of the puzzle that will make it all fall into place. The lasting hold *Citizen Kane* exerts over cinematic enquiry is a tribute to the enduring powers of a film that is fifty years old as I write. Over these fifty years, from the first moment it appeared in the world, *Citizen Kane*'s mystique has been further enhanced by gossip about its origins and polemics over its place in film culture. And in both areas personalities have reigned supreme, above all the two awesome personalities of Orson Welles and William Randolph Hearst, the original of the Kane portrait. Over the last few years, *Citizen Kane* criticism has become less polemical and more rigorous and is now beginning to liberate the film from its own reputation so that it can begin to speak, as it were, for itself.

New research and scholarship is beginning to illuminate some of those areas of debate that had previously been shrouded by polemic as well as by the passing of time. Robert Carringer's book *The Making of Citizen Kane*[2] quietly describes the production history of the film and the collaborative conditions of work under which Welles developed the *Citizen Kane* project, in such a way as to do justice to all creative contributions while also describing just how and why disputes arose. His book puts paid to the 'Who is the true author of *Citizen Kane*?' debate, with a researched rather than rhetorical assessment of Welles's central role, while also illuminating the complexities of authorship in Hollywood, studio system, cinema. And historical scholarship is also beginning to place *Citizen Kane* within its cultural and political context, bringing a 'monstre sacré' down to earth without diminishing either its cinematic power or its critical interest. Quite the contrary, to place *Citizen Kane* in the context of New Deal culture and to show Welles to be inextricably involved in the politics of his moment, reveals other, enhancing, aspects of both director and film; no longer need either seem simply to be brilliant, mutually reinforcing, one-off, flash-in-the-pan oddities. Very suggestive work on Welles and his political context has

appeared in a special issue of *Persistence of Vision*, containing the proceedings of a conference on Orson Welles held at New York University in 1989.[3] James Naremore's *The Magic World of Orson Welles* has not only an extremely perceptive chapter on *Citizen Kane* but also invaluable documentation on Welles's 'essential liberalism and intense concern with political affairs'.[4]

Citizen Kane has been surrounded by extra-textual myths and legends from the moment of its birth. It is as though the flamboyant nature of its subject, a legendary and enigmatic tycoon, came to haunt both its creator and the film itself. Both were constantly to be beset by controversy, starting from Welles's arrival in Hollywood in July 1939 to sign the contract between the Mercury Theatre and RKO that immediately achieved legendary status. Welles's adaptation of Shakespeare's history plays, *Five Kings*, had just flopped, leaving him badly damaged financially, critically and personally. All the same, he claims that he had no particular interest in moving to Hollywood and, had it not been for the favourable conditions and creative freedom guaranteed in the contract, he would have turned down the offer from George Schaefer, recently hired to bring outside, East coast, talent to RKO.

Schaefer was bitterly attacked in Hollywood for putting the cat of genius among the pigeons of the entertainment industry. As it was, he contracted Welles to write, produce, direct and act in two films without studio interference and with rights over the final cut, keeping control only over the choice of story and the budget if it ran over $500,000. The first project, Conrad's *Heart of Darkness*, had to be shelved when it came out way over any possible budget at the end of the pre-production period. It was then, in early January 1940, that the industry gossip began to triumph at the discomfiture of the genius and the just deserts of management irresponsibility. In this atmosphere, heightened as another still-born project, *The Smiler with a Knife*, failed publicly, the *Citizen Kane* idea brought a last-minute rescue. When Welles finally launched what was to be the only project he managed to make with the freedom guaranteed by the terms of his fantastic contract with RKO, two industry professionals joined his team from outside the studio. In addition to Gregg Toland, on loan from Goldwyn Studios, Welles brought in Hermann Mankiewicz as his screenwriter.

The question of cinematic authorship, whether the director or the screenwriter should be considered to be the creative core of a film, has been fought over the body of *Citizen Kane*. Controversies about creative responsibility for the script, before the film was finished, over the writer's credit. Rumours that Welles was about to claim sole credit, or that he was going to eliminate the screenwriting credit altogether, were countered by Mankiewicz, who easily whipped up support in the Hollywood community. Finally, in a compromise move, an equal screenwriting credit was proposed to the Guild of Screen Writers and agreed. In 1971 Pauline Kael revived and refuelled old embers of the credit controversy with an ulterior and polemical motive: to counter the auteurist tendency in film criticism. Her – partisan – presentation of Mankiewicz's script as the source of *Citizen Kane*'s importance in the cinema[5] was then answered by Peter Bogdanovich's equally partisan presentation of Welles's case.[6] All these debates, and the events surrounding them, add to the mystique that has encrusted the history of *Citizen Kane*.

Competition over who first came up with an idea seems less significant once the idea has been transformed into film. Although it might be of academic interest to trace an idea to an origin other than a director's decision and vision, the film itself is not affected by contested attributions of authorship. For instance, the opening shots of *Citizen Kane*, on which a number of critics have based an argument for the 'readerliness' of the film, are given exactly in the Mankiewicz version of the script, 'American', that he and John Houseman, Welles's partner and co-founder of the Mercury Theatre, took back to RKO after several months of work, without Welles's participation or collaboration. On the other hand, the concept and camera strategy used in the opening shots is undoubtedly in keeping with Welles's aesthetic interests and expressive of the style he was evolving for his first foray into cinema. On the other hand again, according to Carringer, the opening may have been influenced by the first shot of Hitchcock's *Rebecca*, just premiered in Hollywood, which also sets up a mysterious space and an investigative camera-eye. Carringer demonstrates that Welles was always open to available influences, whether in the form of ideas or the technical skills of his collaborators. But all the elements and influences he amassed were rigorously filtered through his creative intelligence

Overleaf: Welles on the set with Dorothy Comingore; Gregg Toland is fourth from the right

1 1

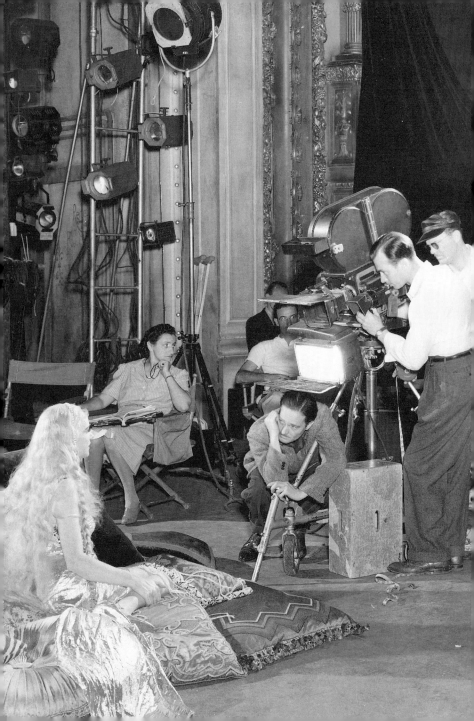

and instinct, so, in the last resort, what stayed in and what was junked from the project, at all stages of its development and production, was the result of his choice. If the opening of 'American' stays unchanged throughout the extensive revisions and rewrites that finally gelled into the script of *Citizen Kane*, it was because that was the way Welles wanted the film to open.

The innovative cinematic style of *Citizen Kane* has been noticed and debated from the first reviews it received. Its cinematographer, Gregg Toland, received both a major screen credit and critical attention unprecedented for a lighting cameraman in studio system cinema. Welles, from the very beginning of his time in Hollywood, was interested in a camera style that could carry the flow of action and narration. When Toland, on his own initiative, offered to shoot *Citizen Kane*, Welles had found someone who could transmute his fantasies about film into practical reality. Toland was already a distinguished, Academy Award-winning cinematographer who had been evolving his own idiosyncratic lighting/camera style for some years. The extended pre-production period that Welles's agreement allowed gave Toland the opportunity to develop his style systematically and in close collaboration with a director who knew very little, had vision and was ready to learn. The deep-focus style that so impressed André Bazin when the film was first shown in Paris after the war was a logical solution to Welles's wish to maintain continuity of action by eliminating reverse angles and intercutting. The style developed, as it were, both out of the positive factor of Toland's awareness of new technical possibilities and from the negative factor of Welles knowing what he wanted to avoid. From Toland's own essay, 'How I broke the Rules in *Citizen Kane*',[7] to Patrick Ogle's thorough study of the technological developments that Toland exploited in order to break the rules,[8] to Barry Salt's measured reassessment of the film's innovations,[9] *Citizen Kane* has provided the impetus for invaluable research and discussion about relations between technology, style and the aesthetics of cinema. These accounts show how unusual production circumstances allowed both pre-existing and recent technological changes to be brought together, consciously and systematically, in order to create a new look for film.

It seems daunting, in the light of *Citizen Kane*'s legendary history

and the polemics and critical controversies that have raged around it, to write about it yet again. And now, on its fiftieth birthday, it is once again being exhaustively celebrated. There are two excuses for this further addition to *Kane* criticism. First, I have tried to bring a European perspective to the film in order to highlight the representations and themes associated with Europe that run through it, and which, I think, draw attention to the precise historical moment at which the film was made. Work started on the *Citizen Kane* script in February 1940, during the 'phoney war' period that followed the German invasion of Poland in September 1939. While work continued on the script in the spring and early summer of 1940, the German offensive moved across Europe and *Citizen Kane* went into production on 29 June during the bleakest moments of the war, between the fall of France in May and the Battle of Britain, a last stand against Hitler which extended from July to September 1940. As Europe appeared to be falling inexorably to fascism, the battle between intervention and isolationism was bitterly engaged in America, with President Roosevelt unable to swing the nation into support for his interventionist policy. And, when *Citizen Kane* opened in New York in May 1941, Pearl Harbor was still six months away. Not only was the war in Europe the burning public issue of the time, it was of passionate personal importance to Orson Welles, with his deep involvement with European culture and his long-standing political commitment to Roosevelt's New Deal and the anti-fascist struggle.

This contemporary background is not explicitly spelled out in the film, but an awareness of its historical moment inflects its interpretation away from intangible questions about human nature and character and towards questions about the nature of American politics encapsulated in a mythic, symptomatic character. In the rhetoric of *Citizen Kane*, the destiny of isolationism is realised in metaphor: in Kane's own fate, dying wealthy and lonely, surrounded by the detritus of European culture and history. Hearst, the most important source for the figure of Kane, as a leading isolationist and opponent of the New Deal, forged a link between contemporary politics and the pre-New Deal political system in which different elite interests competed for control. From this perspective, a swing towards the isolationist lobby would have put the political clock back ten years at home while ensuring the victory of

fascism abroad. Indeed, a victory for the old breed of American politics could herald a victory for a new breed of American fascism. But of course, in *Citizen Kane*, Kane's political career crumbles and falls into ruins, which leads to my second excuse for this essay.

This essay is an experiment in method. I am applying the film theory and criticism of my generation to a film that has been taken through the mill by each generation since it appeared fifty years ago. As the main influences on my thought have been psychoanalytic theory and feminism, both have strongly inflected my analysis of *Citizen Kane*, not just in terms of the content – how the film depicts women and uses Freud – but as a film that challenges conventional relations between screen and spectator and constructs a language of cinema that meshes with the language of the psyche. In applying psychoanalytic theory to *Citizen Kane*, I am using a particular critical approach, concentrating on the film's textual evidence, and I have not tried to deal with the question of how deliberately the themes I discuss were written in by Welles and/or Mankiewicz. To my mind, both the structure of the film and its politics would indicate that they were, but whether in the spirit of a private joke or as serious comment seems hard to decide.

Although *Citizen Kane* is not an obvious candidate for feminist polemic, either for or against, it is interesting to see how the film cuts across conventional Hollywood investment in the visualisation of the feminine, not, of course, in the spirit of feminism but with interesting aesthetic consequences that are relevant to feminism. Feminist film criticism's alliance with psychoanalytic theory helped to create a critical theory of decipherment, which was directed, first and foremost, at the decipherment of unconscious meanings invested in images of women. From this point of view, the feminist critic feels like an investigator, and psychoanalytic theory like a code-book key which can at least begin to crack the cipher. *Citizen Kane* is a film which is built around the pleasures and problems of decipherment not only, explicitly, in the main subject of the film (the journalist's investigation of the Kane enigma), but also in the fact that it builds in a deciphering spectator by means of its visual language and address. And then, its many different levels contain semi-hidden, almost subterranean, themes and symptoms of Oedipal conflict and sexual difficulty which can only be investigated, deciphered and brought into visibility through psychoanalytic theory.

Psychoanalytic theory understands a symptom to be a kind of cipher which appears in the conscious mind but the key needed to unlock its unconscious meaning is lost. From all these different angles, *Citizen Kane* poses a simultaneously unfamiliar and familiar challenge for psychoanalytically influenced feminist film theory. The attempt to figure out a puzzle or decode a rebus not only approximates metaphorically to any analytical process but also harnesses the drive of curiosity generated by the enigmatic. Feminist film theory has had to shift fascination with the eroticised and enigmatic female figure to fascination with decoding the meanings these figures disguise. *Citizen Kane*, however, presents a kind of back-to-front challenge to feminist criticism.

One of the ways in which *Citizen Kane* seems strikingly anti-Hollywood is the absence of the glamour effect generated by a female star. (Toland, according to Barry Salt, was not thought of as a 'good' glamour photographer.) And this absence becomes obvious when *Kane* is compared to *The Lady from Shanghai*, the film that Welles made in 1947 starring his, by then, ex-wife Rita Hayworth. Whereas in *The Lady from Shanghai* the audience shares Michael's fascination with Elsa, and is absorbed into the erotic atmosphere she generates, in *Citizen Kane* it is Kane himself who holds the centre of the visual stage. The scenes in which Susan performs in the opera actually undercut and caricature the figure of woman as erotic spectacle. And whereas, in *The Lady from Shanghai*, the film's central enigma gradually crystalises around Elsa, in *Citizen Kane* the film firmly displaces its enigma away from a simple equation with the feminine. Welles's own towering presence on the screen provides a magnetic draw for the spectator's eye and leaves little space for sexualised voyeurism. This displacement leads into another kind of fascination and opens up a space for the voyeurism of curiosity. Liberated from its erotic obsession with the female figure, cinematic voyeurism is displaced and replaced by a different currency of exchange between screen and spectator.

Curiosity has to have an object, an enigma to arouse it. In *Citizen Kane*, the central enigma of Kane himself is neatly encapsulated in, or displaced on to, 'Rosebud', which then becomes the focus of the journalist/investigator's quest. But the enigma is never solved for the world on the screen, either through the protagonist's investigation or

the witnesses' testimony. Welles splits the spectator apart from the screen and upsets any easy assumption that a story's resolution will be provided by the characters' transcendent understanding rather than be found by the spectator in the screen image. Because the overt solution to the 'Rosebud' enigma only appears in the film's closing seconds, many important signs and clues set up earlier will probably have gone by unnoticed on a first viewing. *Citizen Kane* has, built into its structure, the need to think back and reflect on what has taken place in the main body of the film as soon as it finishes. Although the enigma may have been solved at one level, the spectator is still challenged by the journalist Thompson's statement, 'I don't think a word can sum up a man's life...' And when the camera tracks into the furnace and supplies the 'missing piece of the jigsaw puzzle', it throws everything that has led up to that moment into new relief. Anyone whose curiosity has been truly engaged by the film must find themselves wanting to see it again. The next and subsequent viewings are bound to be experienced quite differently from the first. The conventional alignment between the director's concept of cinema, the camera look and spectator eye finds a new dimension and they become partners, as it were, in uncovering the different layers that make up the film.

The music also plays its part. Bernard Herrmann wrote about the necessity for musical leitmotivs in *Citizen Kane*. There are two main motifs. One – a simple four-note figure in brass – is that of Kane's power. It is given out in the first two bars of the film. The second motif is that of 'Rosebud'; heard as a solo on the vibraphone, it first appears during the death scene at the very beginning of the picture. It is heard again and again throughout the film under various guises, and, if followed closely, is a clue to the ultimate identity of 'Rosebud' itself.[10]

Citizen Kane is concerned with creating a way of seeing based on a pleasure of curiosity, to be satisfied by seeing with the mind, and this can only be achieved by offering the audience their own, autonomous entry into the film text. But beyond the pleasure there is also a demand to reflect back on history through a particular history and, perhaps, to extract a political message. In this sense, the film's politics informs its mode of address.

Citizen Kane makes a particular call on the spectator's powers of 'reading' the image. It conjures up the comparison that has been made

between the language of film and the language of hieroglyphs. Miriam
Hansen has made this point: 'The model of hieroglyphic writing seems
useful [for film] because of its emphasis on the irreducibly composite
character of the hieroglyphic sign (consisting of pictographic,
ideogrammatic and phonetic elements) and its constitutive plurality of
meanings.' And she draws attention to the connection made by Freud
between hieroglyphic writing and the figurative script of dreams: 'Both
these textual phenomena in their way resist immediate perception
and understanding, requiring instead an activity of reading and
interpretation.'[11]

The language of the mind, with its dream images, allegorical
objects, scenarios of desire, frozen memories and so on, finds a
resonance in the language of cinema. In cinema, objects, gestures,
looks, *mise-en-scène*, lighting, framing and all the accoutrements of the
filmic apparatus materialise into a kind of language before or even
beyond words. *Citizen Kane*'s originality lies in its self-conscious
awareness, even exploitation, of this process. For instance, when

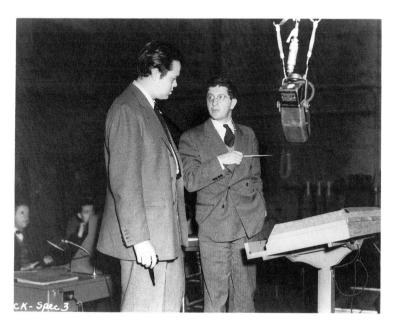

Welles with Bernard Herrmann

Thompson opens the Thatcher memoirs, the white of the page dissolves into the snow and the young Kane's figure materialises from the blank screen, as he sleds down the slope, like the inscription of a memory. The film also plays with differences of scale. When Kane holds the little glass paperweight in his hand, it is as though he were actually holding the memory of his parents' log cabin, which also plays its own real part in the *mise-en-scène*. And, as the camera moves through the skylight into the El Rancho nightclub, Susan appears underneath as though she too were enclosed in the space of her memory and mourning. These cinematic images inform and affect each other, shifting their meanings and acquiring and passing on resonances, sometimes with the help of music or repetition, so that they seem to set up a network of links backwards and forwards through the film's narrative chronology and its different layers.

Kane criticism has paid particular attention to the film's mode of address. For André Bazin, engagement between spectator and screen was an effect of the film's composition in depth. Dramatic juxtapositions are composed within the frame, and a shot then lasts long enough for the spectator to work out the relationships between the characters and extract the poetic and emotional implications of the scene. Bazin argued that this kind of composition gave the spectator's eye and mind an autonomy that both montage and the cutting conventions of commercial cinema (especially after the coming of sound) denied: 'Classical editing totally suppresses this kind of reciprocal freedom between us and the object. It substitutes for a free organisation, a forced breaking down where the logic of the shots controlled by the reporting of an action anaesthetises our freedom exactly.'[12] Dudley Andrew argues that Bazin's position on deep-focus style was based on an ethical assumption. It was right, in the moral sense of the word, that the spectator should engage and wrestle with the meanings on the screen and 'exercise at least a minimum of personal choice. It is from his attention and his will that the meaning of the images in part derives.'

Noel Carroll, in his article 'Interpreting Citizen Kane',[13] makes a very useful division between critics' responses to the problem of 'Rosebud'. He organises them into two broad groups. One position is that the puzzle of 'Rosebud' has a specific meaning that can be identified

to solve the mystery of Charles Foster Kane's life. The other position is that the enigma of human beings is far too intricate and complex to be reduced to such a simple explanation. Carroll argues that both positions can be extracted quite validly from evidence in the film, but then transforms the issue from one of character to one of reading the film. He says:

> I have stressed that the two leading interpretations of Kane's life – the enigma interpretation and the Rosebud interpretation – are simple as well as culturally well entrenched. This is appropriate for the role they play in the dialogical structure of the film. For, if I am right, the point of the film is to involve the movie audience in a conflict of views about life. And in order to be functional in this respect, the views must be relatively simple, somewhat commonplace, and near or on the surface of the work. Recondite or complex views would lack the salience for a movie audience to pick up and enter into debate.

And:

> ... the dialogical structure of the film's narrative also makes possible a level of audience participation in the film – this time, however, by articulating, in manner of speaking, multiple planes in the film's conceptual space ... there is no guarantee that every spectator will be sensitive to this play of interpretation or engage in it. ... Nevertheless, the structural modifications are there, and they allow, rather than mandate, a level of, albeit limited, audience participation of a sort rare in Hollywood films.

Long before he got involved with the *Citizen Kane* project, Mankiewicz had been toying for some time with what he called a 'prismatic' narrative, in which the story of a powerful, contradictory man would be told through the eyes of those who knew him well and whose experiences and perceptions would be at variance. In *Citizen Kane*, five blocks of flashbacks are recounted by five witnesses and Thompson's interviews are organised to tell the story of Kane's life in roughly chronological order. The witnesses, apart from Thatcher who

speaks posthumously through his memoirs, give their own personal insights and reflections on Kane in the framing story, in which the reporter Thompson attempts to piece together the enigma 'Kane'. In the flashbacks, the audience is shown the scenes that Thompson only hears. All these characters' accounts, which make up the main bulk of the film's narrative, are – quite understandably – preoccupied with personal relations, misunderstandings, hopes, love, ambition, disappointment and so on. And their accounts are, also quite understandably, inconsistent and contradictory. The prismatic, fragmented narrative structure is narrated in such a way as to highlight the partial, incomplete nature of human understanding and perception.

As a labyrinth *Citizen Kane* has to create false trails, as an enigmatic text it has to give the spectator clues to decode. It is quite easy to be distracted by the film's complex characters, and lured into thinking that multiple viewpoints and inconsistency of evidence offer the keys to the Kane enigma. The fragmented narration and posthumous investigation of the journalist all point in this direction. In a further manifestation of anti-Hollywood spirit, *Citizen Kane* defies normal processes of identification, and confounds the implicit moral judgments they depend on, leaving critics and the general public stripped of the dramatic reassurance which a straight moral binary opposition between villain and victim provides. Within a popular culture tradition (still today, almost as much as in 1941), this narrative strategy comes across as anti-heroic and anti-Hollywood. Identification is first and foremost confused by Welles's own powerful performance as Kane. Faced with the figure of Kane, the audience wants to assess the comparative credibility of the witnesses, to attempt to understand Kane as either hero or villain, victim or oppressor. But the film constantly frustrates identification. One is left with a sense of weighing up the characters' moral worth as though on judgment day, and never managing to balance the scales.

It is here that critics have often turned to psychoanalysis, in an attempt to make sense of the character within the psychoanalytic framework that the film clearly offers. But most stay preoccupied with the nature of character and behaviour, weighing up morality from a more and more complex point of view, and still approaching Charles Foster Kane as though there might be a coherent explanation for his

monstrousness or an excuse that might let him off the hook. It is hard for these arguments to escape from the good/bad, victim/oppressor binary opposition. And so the debate continues. Although it is uncertain which he is, victim or oppressor, in these terms he must be one or the other.[14]

Characters do not provide a reliable or rewarding means of access to the film's enigmas. The clues spread through the story on the screen, hidden in all the varied elements that make up a film: camera movements, objects, gestures, events, repetitions, *mise-en-scène*. And among these elements, the characters are only one more link in the chain, another piece in the jigsaw puzzle. So *Citizen Kane* upsets our usual sense of hierarchy in story-telling, in which the ratio between people and things tends to be organised along an anthropomorphic bias. In *Citizen Kane* things loom up and occupy a privileged space on the screen and in the story. Quite beyond Bazin's conception of the 'democratic' nature of deep focus, the film is juggling with American myth, politics and the collective psyche. The spectator is left to 'figure out' what is going on (beyond, in Lucy's famous words to Charlie Brown, 'Rosebud's his sled') and pick up hints at messages that are quite clearly not delivered by Western Union.

By its very use of inconsistency and contradiction, the film warns the audience against any reliance on the protagonists as credible sources of truth, and it attempts to deflect understanding away from character, away from a dramatic interplay between people and their destinies. This undercutting of character identification and credibility also undercuts spectators' conventional dependence on screen characters to create a moral and orderly universe, in which disorder and immorality, contradiction and inconsistency, are resolved as the narrative is resolved. The audience is left without a reliable guide to find their own means of interpreting the film. They can come to their own conclusions, but only if they break through the barrier of character as the source of meaning, and start to interpret clues and symptoms on the screen as might a detective or a psychoanalyst. It is not the characters as autonomous individuals, even the central character, who should be on the couch. Once the characters fall into place as just one element in an intricately patterned web, the film's own internal consistency and logic, independent of character, come clearly into focus. Charles Foster Kane

is no longer an enigma in himself, no longer a character with any relation to flesh and blood. From this perspective, *Citizen Kane* is a celluloid rebus, within which the central enigma 'Rosebud' is first and foremost a clue to the only means of understanding the film's central enigmas; that is, a decoding of its sounds and images. To enable and emphasise exchange between screen and spectator, the film adopts a style suitable for an active, inquisitive spectatorship in which the pleasure of looking is also the pleasure of decoding.

In addition to its play with character, the film sets up other red herrings and false trails that promise an easy short cut to the centre only to fade away. For instance Rawlston, the editor of the 'News on the March' newsreel, dispatches Thompson on his quest with the words 'Rosebud: dead or alive. It may turn out to be a very simple thing.' The next shot shows a poster of Susan's face in close-up, illuminated by a flash of lightning, in a broad hint to the audience at a link between this image and the statement before. The poster can only be seen by the audience. The shot sets up a complicity between screen and spectator that is heightened by a sweeping crane shot, the opening shot of Thompson's investigation. Moving down through a skylight, to find Susan in the enclosed space below, the investigative drive of the camera interacts with the *mise-en-scène* to materialise both the space of the film's enigma and the camera's privileged role in the film's subsequent unfolding of its enquiry into the enigma. But the hint at a snap solution to the 'Rosebud' enigma is too broad and the juxtaposition too obvious. The spectator instinctively rejects such an easy putting together of two and two and suspects they make five. But the film text has made a gesture to itself as a source of meaning and discovery independent of its protagonists. The responsive spectator senses an invitation to start figuring out the enigma with the camera's collaboration.

The film's opening sequence sets up the relationship between camera and spectator and establishes it as one of curiosity and investigation. When the film's title fades from the screen and the initial image takes its place, the audience is swept into the story with an interdiction and a camera movement. A sign saying 'No Trespassing' can be easily seen through the murky lighting; and a wire fence fills the screen, barring the way forward. This sign, although rationalised through its place on the gate of the Xanadu estate, directly addresses

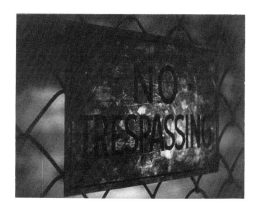

The opening of the film

the audience. Everyone knows that prohibited space becomes immediately fascinating and that nothing arouses curiosity more than a secret. And in response, without even hardly pausing on its first image, the camera cranes up and over the top of the fence, moving forward through a series of lap dissolves over grounds of neglected grandeur, towards a fairytale castle on the top of a hill.

The camera's movement functions both literally and figuratively. It establishes a place and a mystery, but it also gives a visible rendering of the opening of a story as an opening of a narrative space. The space of the story is depicted as an enclosed place from which the audience is excluded, and the camera's effortless passage from outside to inside acts like a magic eye and opens a way into the storyteller's world and imagination. The camera as a magic eye, transcending space and transgressing prohibition, becomes an investigating eye, moving inexorably into the story and zeroing in on the castle, the object of its curiosity. Another mysterious space, frightening and alluring, is thus enclosed within the first. The camera then reveals, in extreme close-up, the little glass ball which contains within it another space: the log cabin, which is the mother's space. The womb appears within the tomb.

The end of the film reverses the camera movement, so the space that opened up the story is symmetrically closed, returning the audience back to the original position, outside the wire fence, ultimately back into the auditorium, back to square one, the same as they were but different for having undergone the experience of the previous two hours. Not only is the space on the screen a metaphor for the opening and closing of the narrative, but the camera itself is like a guide, luring the audience in and arousing the desire to know that successful storytelling depends on. This camera movement also returns with the crane shot into the 'El Rancho' bar. And Naremore comments on the way the camera tracks in an inquisitive, almost voyeuristic movement after Kane and Susan as they go into her apartment.

There is an echo, in this narrating camera, of the grand experiment that Welles had planned for his first Hollywood project, the adaptation of *Heart of Darkness*. The project grew out of the Mercury Theatre's radio series 'First Person Singular', in which novels built around a narrating 'I' were adapted for dramatic performance combined with the storyteller's 'voice-over'. *Heart of Darkness* had been one of

these. To transform the first-person narration into the new medium, cinema, Welles wanted to shoot the film with the camera as the eye of the 'I', using a subjective camera throughout, of the kind later used by Robert Montgomery in *Lady in the Lake*. The difficulties involved in shooting the film in this way resulted in the greatly inflated *Heart of Darkness* budget which caused it to be shelved. The film was to have been introduced by a prologue in which Welles himself would give an illustrated lecture on subjective camera and explain directly to the audience that the camera's point of view was also theirs. Carringer says:

> To Welles's explanatory narration, the camera would adopt the points of view, successively, of a bird in a cage, a condemned man about to be electrocuted, and a golfer driving a ball. Then it would take up Welles's point of view from the screen, looking into a movie audience made up entirely of motion picture cameras. In the final shot, an eye would appear on the left side of the blank screen, then the equals sign, then the pronoun I. The eye would wink, and a dissolve would lead to the opening shot of the film.[15]

The opening of *Citizen Kane* offers a more sophisticated version of subjective camera. As the camera's look is not associated with a character, a literal first-person participant in the story, it takes on the function of narrator outside the world of the story but still assimilates and represents the audience's eye as they look at the screen. Later in the film the shadowy presence of Thompson, the investigating journalist, acts as a surrogate for the audience's curiosity, carrying the narrative forward and precipitating the film's flashbacks to the past. He is never, however, given the powerful look that is marked by assimilation to a subjective camera. Just as a more manageable mediator seems to appear on the scene, *Citizen Kane* consolidates its radical, unusual appeal to an autonomous, active and investigative spectator. Thompson cannot do more than listen to his witnesses' memories. He cannot break out of the film's present tense. Similarly, during the flashback sequences, the *mise-en-scène* goes beyond the literal vision of the five witnesses, and the film's images, at certain moments, show more than the characters on the screen can see or understand. Only the camera and the audience have a

vision that will allow them to figure out the film as puzzle. The opening sequence signals this privileged relation between the two, giving the audience a cue or hint, as it were, to use their own eyes and powers of decipherment and not to fall back into habits of dependence or to expect their surrogate on the screen to understand the language of film.

The opening sequence also establishes the motif of contradiction that runs through the film. 'News on the March', in particular, piles antinomy on antinomy to describe Kane. But the very first shots of the film start swinging a pendulum between irreconcilables. It is impossible to be sure about either the historical or geographical setting of the film. As the camera moves up towards the one lit window in the castle, it passes through a mysterious landscape which the spectator cannot reconcile into a coherent picture. Spider monkeys are juxtaposed, for instance, with gondolas, while the scene and the accompanying music on the soundtrack are redolent with Gothick menace. The *mise-en-scène* is enigmatic, before any specific narrative enigma has been established. The appeal to read the scene is made, and also frustrated. So, although the spectator is encouraged to take note of the visual clues on the screen, the nature of the image simultaneously imposes a postponement of the gratification of understanding.

When the camera arrives at its destination, the light in the window suddenly goes out and then returns with a long dissolve that reveals the camera to be now inside the turret room, upsetting conventional transitions of time and space. Then the scene builds up to the enigma that will activate the movie's hermeneutic drive. Snow fills the screen. The little log-cabin surrounded by snow is seen first in extreme close-up, then in the glass ball in Kane's hand, followed by a huge close-up of moustachioed lips which pronounce the word 'Rosebud'. The glass ball rolls out of the hand that holds it and shatters on the floor. Just as the spoken word 'Rosebud' completes this sequence, its complementary image precipitates the film's coda. When the camera closes in on the little sled burning on the bonfire of Kane's memorabilia, the lettering 'Rosebud' and a little painted rose fill the screen. The whole intervening length of the movie separates the two and then brings them together. The symmetry between the opening movement of the camera and its closing retreat to outside the wire fence contains this – other – symmetry.

While the question of the extent to which Hearst was a model for Kane added, of course, a further level of enigmatic encrustation, his presence, both shadowy and blatant, lies at the political heart of the film. Hearst himself contributed the first dramatic, public chapter of *Citizen Kane*'s extra-cinematic history in the vendetta waged against the film by the Hearst press just before and after its release. Louella Parsons's outraged exit from the special screening organised for her benefit first signalled the Hearst camp's implicit acknowledgment of the portrait. A delegation of top Hollywood producers and studio heads offered RKO a million dollars to burn the negative before the film was released. Although there is no indication that Hearst even knew of this initiative, it is a sign of the power he still exerted in Hollywood and the ties built up over long years of lavish entertaining at San Simeon. Hearst papers, which could easily determine the success or failure of a new release, were forbidden even to mention any RKO production after the *Citizen Kane* scandal leaked out. The threat of this kind of blacklisting successfully stopped distributors from promoting *Citizen Kane* and the film was ostracised to RKO's own outlets. In this sense Hearst, or the threat of Hearst, did serious damage to the film financially and its lack of box-office success probably hammered the first nail into the coffin of financial catastrophe that increasingly soured Welles's relations with Hollywood.

There has been considerable debate over the origin of the Hearst model, and considerably more about its accuracy and extent. John Houseman describes Mankiewicz's interest:

> Total disagreement persists as to where the Hearst idea originated. The fact is that, as a former newspaper man and an avid reader of contemporary history, Mank had long been fascinated by the American phenomenon of William Randolph Hearst. Unlike his friends on the left, to whom Hearst was now an archenemy, fascist isolationist and a red baiter, Mankiewicz remembered the years when Hearst had been regarded as the working man's friend and a political progressive. He had observed him later as a member of the film colony – grandiose, aging and vulnerable in the immensity of his reconstructed palace at San Simeon.[16]

In the years before Welles went to Hollywood, Hearst's vast empire was barely staving off financial collapse. In 1937 his financial affairs were removed from his direct control and put in the hands of a 'Conservation Committee', and he was forced to auction off some of his immense collection of art objects. His difficulties had attracted considerable attention. In March 1939 he was the subject of a *Time* magazine cover story, and around the same time Aldous Huxley's Hearst novel, *After Many a Summer*, was published. In his Welles biography, Frank Brady describes a dinner, at which Welles was present, held to celebrate publication of the book. The model for the portrait and the consequent impossibility of turning it into a film was discussed. It was when 'the miraculous contract had three and a half months to run and there was no film in sight' (in John Houseman's words) that the Hearst idea was floated somewhere between Welles and Mankiewicz. But when Welles, who was definitely on the left, decided in 1940 to use Hearst as the basis of his first film, he was interested in more than the story of a grand old man of capitalism who was running out of time and money. Hearst still held considerable sway and influence over the Republican Party, which represented consolidated and determined opposition both to the New Deal and the United States' entry into the European war. In 1940 both these issues were still topical or very recent history. In 1936–7 the Supreme Court had made a major attempt to block and undermine New Deal social legislation; and the isolationist lobby was actively promoting popular organisations 'for peace'. The Hearst-sponsored 'Mothers of America' had more than a million members when the war broke out. And in November 1940 FDR would run his third presidential campaign.

In this context, the Mankiewicz idea was refracted through Welles's very contemporary political perspective. If Mankiewicz wanted to restore complexity and multi-dimensionality to the cardboard cut-out image of Hearst as reactionary, the final film turns this project upside down and Hearst's progressive youth takes on a very different aspect. This radical, populist phase is depicted as the product of fictional psychological factors as much as political conviction. While the Hearst model is important to the film on a now dated and superficial level as an act of iconoclasm, its strength lies not in personal detail but in its generality. The identifiable Hearst persona is used as a

springboard for reflection on wider issues of American politics and myth, especially as personified by the yellow press. And then this broad perspective narrows down again to the personal, not this time to the interiority of William Randolph Hearst, but to a fictional American tycoon, complete with an unconscious which might, perhaps, be symptomatic of the repressed in American capitalism and its history.

Although Welles vigorously denied that he had used Hearst as a model for Kane, especially in his article '*Citizen Kane* Is Not About Louella Parsons's Boss',[17] the accuracy of the portrait was generally recognised and then further confirmed by the plagiarism suit brought against Welles in 1949 by Ferdinand Lundberg, the author of the biography *Imperial Hearst*. He considered *Citizen Kane* to be the film of his book, but the case was left undecided because of a hung jury. To my mind, the Hearst model is of great importance for *Citizen Kane*, both in its accuracy and in its deviations. In its accuracy, it comments on a major and recognisable political figure of the far right from the political perspective of the liberal left. The deviations into fiction are concentrated particularly at the beginning and end of Kane's life: in his humble birth in a log cabin, his separation from his mother and his relationship with and separation from Susan Alexander. Although there were important similarities between the Kane/Susan relationship and the Hearst/Marion Davies relationship, the deviations are crucial. Neither in Susan's humiliating failure as an opera singer and attempted suicide nor in the breakdown of her marriage was there any real-life model. Marion Davies was a successful silent movie actress in her own right, although suffering from Hearst's possibly excessive backing, and she and Hearst lived happily together, unmarried, until his death in 1951. The fictional elements allow for the depiction of Kane's unconscious. In this sense, the deviations from the Hearst model which originate in the log cabin and return particularly in the opera sequence tie together the mythological and psychoanalytic themes that run through the film. I will argue that the psychoanalytic themes concentrate on Oedipal trauma and fetishism which then lead outwards, from the specific instance of one man, into wider issues of the political unconscious of the United States.

In this light, the invention of a psychoanalytic explanation for the famous Hearstian puzzle makes *Citizen Kane* seem particularly

iconoclastic. The fictional unconscious that the film hints at may well amount to nothing more than sophisticated mischief-making on the part of the screenwriter and the director. It could be that it seemed amusing to find unconscious motivations for the eccentricities of a recognisable, ageing and reactionary public figure. After all, the political problem that Hearst represents, that radical youth gives way to conservative old age, is a cliché in a society that pioneered adolescent revolt as a rite of passage into responsible, American, citizenship. The political atmosphere of the New Deal era throws light both on the appeal that a Hearst-based script would have for Welles and on the wider implications of its psychoanalytic undertone.

. .

Welles had come of age, as it were, and risen to be an outstanding figure in American theatre at a time when extraordinary opportunities had been created by the New Deal's cultural policy, orchestrated through the Works Progress Administration.[18] Although the WPA was primarily directed towards combining full employment with the renovation of the nation's decaying infrastructure, its work-relief measures were also extended to the arts. Welles first attracted widespread attention with his production of *Macbeth* for the Negro Theater Project in Harlem, of which John Houseman was then a director. Houseman describes the Federal Theater, which initiated and financed the Project, in the following terms:

> The Federal Theater of the Works Progress Administration, which came to play such a vital part in our lives, was not primarily a cultural activity. It was a relief measure conceived in a time of national misery and despair. The only artistic policy it ever had was the assumption that thousands of indigent theatre people were willing and able to work and that millions of Americans would enjoy the results of this work if it could be offered at a price they could afford to pay. Within a year of its formation the Federal Theater had more than 15,000 men and women on its payroll at an average wage of less than $20 a week. During the four years of its existence its productions played to more than 30 million people in more than 200 theatres as well as

portable stages, school auditoriums and public parks all over the country.[19]

Welles and Houseman were later commissioned by the Federal Theater to run their own company, which they named after its WPA number, Project #891. Welles, returning to the United States from Europe in 1934, at the age of nineteen, was formed intellectually and professionally by the popular front and the theatre of the New Deal. In spite of his outstanding qualities as an actor and director, it is always possible that his career would not have taken off in such meteoric style had it not been for the unprecedented, and unrepeated, circumstances on which it was based.

The Welles/Houseman partnership had started in 1934 with a three-night production of Archibald MacLeish's *Panic*, an anti-capitalist drama about the Crash of 1929. The third night was reserved exclusively for subscribers to *New Theater*, a magazine close to the Communist Party. After the performance, a debate took place that was dominated, in Houseman's description, by V.J. Jerome, head of cultural activities of the USCP. And Project #891 ended in 1937, with an event in which, again, cultural drama nearly overwhelmed the drama on the stage. This was the famous production of Marc Blitzstein's Brecht-influenced *The Cradle Will Rock*. As the WPA had been attempting to cut back its Arts Projects funding, it imposed a moratorium on all new productions just as *The Cradle Will Rock* was due to open. Welles and Houseman tried to present it as an independent production, outside the auspices of the WPA, but in the process fell foul of union regulations which demanded that, as this was a new production, the cast were entitled to renewed rehearsal time. The play, which was performed once in a disused theatre, with the cast, forbidden by their union to appear on stage, speaking and singing from the auditorium, won instant notoriety.

It was in the aftermath of this production that Welles and Houseman gave up Project #891 and founded their own, independent, Mercury Theater. Welles's growing reputation as an actor and director was established at a new level by his Mercury productions. Its success brought contract offers from CBS radio, for which Welles was already working as an actor, and the formation of the Mercury Theater of the Air. One of their regular Sunday evening radio adaptations, *War of the*

Worlds, broadcast for Halloween 1938, put Welles on the front pages of newspapers across the United States, and led George Schaeffer of RKO to invite him and Mercury to Hollywood.

When Welles arrived in Hollywood, he maintained his political commitment to the New Deal and to the Roosevelt presidency, for which he campaigned actively until the President's death in 1945. The New Deal constitutes a massive economic and political watershed in the history of the United States. The Crash of 1929 had marked a crisis point for North American capitalism, throwing doubt on the efficiency, credibility and durability of the system. The radical, socialist, political activists and intellectuals who rallied to Roosevelt had been further disillusioned by the refusal of the capitalist ruling class, which clung to power after the Crash, to recognise and publicly acknowledge the reality of the Depression. The 'Depression' was so named by Herbert Hoover in the aftermath of the Crash to play down its devastating economic and social realities, while he pursued traditional Republican *laissez-faire* policies. It was Roosevelt's willingness to speak the truth about the condition of the country that formed the basis of his political platform and his popularity, and after his first election victory in 1932 his policy of active state intervention in the economy gradually turned the Depression around.

Hearst had supported Roosevelt's candidacy at the 1932 Democratic Primary, at the very last minute, under intense pressure and only when it was quite clear that his competing candidate had no hope of succeeding. His hostility to Roosevelt escalated as the realities of the New Deal were borne in on him, above all increased taxation for the rich and legislation to protect trade unions. Soon the Hearst papers were instructed to refer to the 'Raw Deal'. William Stott describes how the newspapers had reached a low ebb of credibility in the eyes of the supporters of a New Deal:

> Throughout the early thirties the press managed to ignore or belittle evidence of a depression. In the 1936 Presidential campaign, more than 80 per cent of the press opposed Roosevelt, and he won by the highest percentage ever. During the campaign and for years after, many newspapers, including major syndicates, went beyond all legitimate bounds in an effort to

disparage the President and the New Deal. And, as Roosevelt warned the editors, the press lost by it. Public opinion polls in the late thirties suggested that 30 million Americans, nearly one American in three, doubted the honesty of the American press.[20]

Among these newspapers, the Hearst press was particularly vocal. In the 1936 election, which Roosevelt won with the largest majority in the history of the United States, Hearst contributed $30,000 to the Republican campaign and said, 'The race will not be close at all, Landon will be overwhelmingly elected and I'll stake my reputation as a prophet on it.'[21]

By 1939, Hearst was only a shadow of his former wealthy and powerful self. He had lost a large proportion of his fortune due to extravagance and financial mismanagement, and he had lost his political influence as a result of Roosevelt's successful candidacy and presidency. Although he still represented bitter opposition to the principles of the New Deal, Roosevelt's economic recovery measures had succeeded sufficiently by the end of the decade to leave little room for opposition manoeuvre. During the New Deal period, new elements had altered the configurations of contemporary journalism, particularly photo-journalism and radio. Radio was, of course, the medium that introduced Welles to mass entertainment and had an enormous influence on his film work.

With widespread distrust of the established press, the rise of the photograph as a news and documentary medium accompanied the massive spread of radio. Roosevelt himself made use of the radio to speak to the nation in his 'fireside chats'. The new Luce photo-magazine, *Life*, launched in 1936, was an immediate and enormous success. Luce had pioneered a weekly radio programme of documentary and news coverage, 'The March of Time', in 1931, and he extended it to film in 1935. Welles had performed in the reconstructions and dramatisations of events used in both the film and radio versions, and the 'March of Time' with its authoritative voice-over was the source for *Citizen Kane*'s 'News on the March'. The quest for 'Rosebud' that precipitates the quest in *Citizen Kane* emanates directly from the editor's dissatisfaction with the newsreel at the beginning of the film, and the editor himself, Rawlston, represents the new film journalism of

Luce himself. Pauline Kael quotes this piece of dialogue, deleted from later versions of the script, between Thompson and Raymond that dramatises the rivalry between the older and younger generations of news magnates:

> THOMPSON: Well, if you get around to your memoirs – don't forget, Mr Rawlston wants to be sure of getting first chance. We pay awful well for long excerpts.
> RAYMOND: Maybe he'd like to buy the excerpts of what Mr Kane said about him.
> THOMPSON: Huh?
> RAYMOND: He thought Rawlston would break his neck sooner or later. He gave that weekly magazine of yours three years.
> THOMPSON (smugly): He made a bit of a mistake.
> RAYMOND: He made a lot of mistakes.[22]

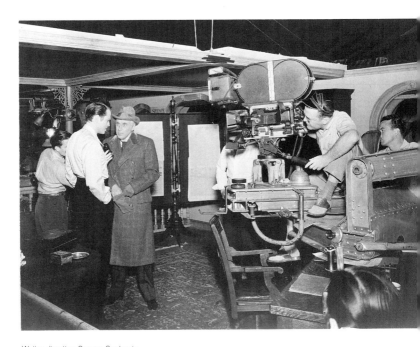

Welles directing George Coulouris

The style in which Gregg Toland shot *Citizen Kane* also contains an implicit homage to the photographic style of the new photojournalism. Patrick Ogle cites James Wong Howe's comments on the influence of magazines such as *Life* and *Look*:

> Howe felt that the tendency towards crisper definition, greater depth, and occasional use of high contrast was primarily due to a change in public taste 'directly traceable to the growth in popularity of miniature camera photography, and to the big picture magazines' in which the public saw the stark realism of miniature camera photojournalism every week. This change in public taste, Howe considered, had evoked a change in photographic style 'so slowly and subtly that we ourselves have been scarcely conscious of it'. [23]

There is a kind of poetic justice in Welles and Toland's use of deep focus in a film which attacks Hearst. The magnate of newspapers and old-style movies is depicted in a new-style cinematography pioneered by the newspapers' new rival, the photo-magazines. On the level of sound, Welles made maximum use of his own experience of radio, the medium beloved by Roosevelt, to create a texture that had never been heard before in the Hollywood cinema. The deep-focus look had also been pioneered separately, but perhaps coincidentally, by Jean Renoir's Popular Front movies in the 1930s in France and would return, in the view of André Bazin, in the Italian neo-realist and leftist cinema of the late 1940s.

By the time Welles and the Mercury players arrived in Hollywood, Hearst was a major opponent of the entry of the United States into the war in Europe. For the left, the threat of fascism was actual and urgent. The Mercury Theater had one of their most important successes with Welles's staging of *Julius Caesar* (subsequently adapted for radio), in which Caesar was portrayed as a contemporary fascist surrounded by blackshirts and the production was lit to create a Nuremberg look in the aftermath of the Nazi rally. In the eyes of the left, the powerful tycoon's press campaign to keep America from joining the struggle against fascism was tantamount to support for fascism. Holidaying in Germany in 1934, Hearst had visited Hitler and

the German press had quoted his approving and friendly remarks. Hearst later claimed that he had been misquoted, and that the only reason for the visit had been to intervene on behalf of the Jews, at the request of his old friend Louis B. Mayer. Throughout this period, the threat of fascism preoccupied Welles and left its mark on many of his abandoned projects. *Heart of Darkness*, his first film project, was adapted to depict Kurtz as a contemporary fascist, and his two other unproduced Hollywood adaptations, one before and one after *Citizen Kane* (Nicholas Blake's *Smiler with a Knife* and Alexander Calder-Marshall's *The Way to Santiago*), were spy thrillers dealing with the fascist threat in Europe and Latin America. His adaptation of Eric Ambler's *Journey into Fear*, on the same theme, did of course eventually go into production, directed by Norman Foster.

Although *Citizen Kane* does not deal with contemporary politics, the theme of fascism and question of the war is saliently summed up in the famous lines spoken by Kane during an interview included in 'News on the March':

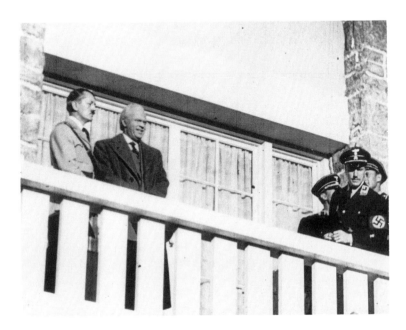

Kane with Hitler

KANE: I talked with the responsible leaders of the Great Powers
– England, France, Germany and Italy. They are too intelligent
to embark upon a project which would mean the end of
civilization as we now know it. You can take my word for it,
there will be no war.

And alongside the commentary:

VOICE-OVER: No public man whom ... Kane himself did
not support ... or denounce. Often support ... then
denounce ...[24]

The fictional newsreel shows Kane appearing on a balcony with Hitler.
The last but one draft of *Citizen Kane* links Kane more explicitly to
fascism through his son, who grows up to become a Nazi and is killed in
a raid on an armoury in Washington. A scene of his funeral at Xanadu
was still in the script as the film went into production. Although *Citizen
Kane* looked back from its own era to the older generation that New
Deal politics had displaced and to the political manoeuvring it had
discredited, the choice of Hearst as the subject of Welles's film was still
politically relevant in the late 1930s. The right-wing opposition to
Roosevelt had emerged as a new threat in the context of fascism.

...........................

When Borges compared *Citizen Kane* to a labyrinth, he found a very
telling image to sum up a narrative structure that twists and turns
through time, through different types of narration, through different
points of view. At the same time the story is overwhelmingly
dominated by a powerful and ambitious man caught up in events
beyond his control, the kind of character who, of course, was of
particular interest to Welles the actor and to Welles the devotee of
Shakespeare.

Although *Citizen Kane* uses the bio-pic genre which was current in
30s Hollywood, it breaks down the literal chronology of Kane's life.
The 'News on the March' newsreel uses a thematic rather than a
biographical approach to Kane's story, beginning with a catalogue of
the fabulousness of Xanadu, then working in turn through Kane's

personal, political and financial careers. And then overlaps and discontinuities break up the flashback narrations. Thatcher's flashback, the first, is divided into three parts: childhood, Kane in the first flush of success at the *Inquirer* newspaper, and Kane after the Crash surrendering control of his empire to Thatcher and the bank. After the Thatcher narration, the film settles down to chronological exposition, but with the Leland narration including events that he could not himself have witnessed, and also including a narration of the opera that overlaps with Susan's. Leland, in this sense, functions more as a raconteur than a straight witness. He has to solve all the problems that accumulate in the middle of the narration, problems that were left pending in the first Mankiewicz script and were worked through by Welles during his rewrite period. The outstanding problem was Emily. Once she had been killed off, Kane's marriage was left without a narrator and Welles's elegant solution, the breakfast montage, is very typical of the streamlining, ordering and shaping that he brought to the script.

The personalised nature of the flashbacks, and their general adherence to chronology, overshadows and disguises the film's underlying dramatic structure. While the narrative is roughly, with some inconsistencies, developed by the linear unfolding of Kane's story, structurally it divides into two parts that cut across the chronological biography with a broad, dominating, binary opposition. Kane's rise and decline separate the two parts narratively, but his relation to male and female worlds separates the two parts thematically. Bernstein tells the story of Kane's dramatic rise to triumphant success; Susan's flashback tells the story of his disgrace and withdrawal. Bernstein's story is set in the competitive, public, male world of newspaper reporting; Susan's is set in the spectacular, cultural and feminised world of the opera and Xanadu. The turning point comes in Leland's narration, which deals with Kane's love life and his political life and the increasingly inextricable connection between the two. The world of public ambition and politics is sandwiched, significantly, between Kane's meeting with Susan and their marriage.

Kane's defeat in his campaign for Governor marks the apex of the rise-and-fall structure and switches the movement of the story. The first part of the film tells the story of Kane the crusader, whose battle with Thatcher – begun when, as a small child, he hit his new guardian with

his sled ('Rosebud') – later widens into a crusade, ironically acting out the name of the second sled ('Crusader') that Thatcher gives him for Christmas. In the second part of the film, Kane invests all his financial and emotional resources into Susan's career in opera, so that, in terms of the film's structure, the *Salammbô* production parallels the *Inquirer*. While the *Inquirer*'s triumph led to Kane's first marriage and to politics, *Salammbô*'s collapse leads to the claustrophobic grandeur of Xanadu. Now Kane's massive enterprise is concentrated on buying and importing art treasures to construct an appropriate environment for his retreat into an isolated, palatial, domesticity with Susan.

Whereas in the first section of the film Kane had championed the interests of 'the people' and used his newspaper to expose the vested interests of capitalism, in the second section Susan, who represents, as Leland points out, 'a cross-section of the American public', is imprisoned in the castle:

> SUSAN: Charlie, I want to go to New York. I'm tired of being a hostess. I wanta have fun. Please, Charlie. Charles, please.
> KANE: Our home is here, Susan. I don't care to visit New York.[25]

Susan tells the story of her departure, but Raymond tells the story of Kane's reaction to her departure and the rage with which he destroys her room and her things. This act of uncontrollable violence recalls his childhood attack on Thatcher. Raymond's narration starts to close in, at last, on the by now almost forgotten question of 'Rosebud', dismissed by Leland ('I saw that in the *Inquirer*. Well I've never believed anything I saw in the *Inquirer*'),irrelevant to Susan ('... when the newspapers were full of it, I asked her. She never heard of "Rosebud"'), pop-philosophised by Bernstein ('Maybe that was something he lost'). And, just as the first flashback enacted the scene with the sled, the last flashback returns to it by means of the little glass ball containing a log cabin in a snowstorm. It is the sight of this object that calms Kane's tantrum and provokes the whispered 'Rosebud' that Raymond overhears then, and again at Kane's death. The film puts its own narrative pattern in advance of its witnesses' ability to understand.

The glass ball makes three appearances, one of them at the very beginning of the film, in Kane's death scene; one at the end, when Susan

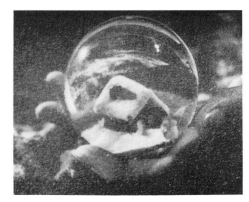

The glass ball
– at the beginning

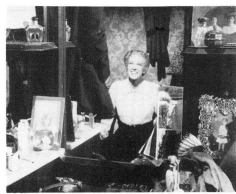

– on Susan's dressing table

– at the end, after Susan has left
Kane

leaves him. As the glass ball belongs to Susan, it first appears in the chronology of Kane's story when she does: that is, in the middle of the film, during Leland's, turning-point, narration. Kane meets Susan, one rainy night, when the differences of class, age and power between them are momentarily eclipsed by mutual misfortune. She has toothache and he gets drenched by a passing carriage. Their meeting stops, as it were, in its tracks Kane's journey back into his past:

> KANE: You see, my mother died, a long time ago. Well, her things were put in storage out West. There wasn't any other place to put them. I thought I'd send for them now. Tonight I was going to take a look at them. A sort of sentimental journey.[26]

This scene includes the second of the only two times in the film that Kane mentions his mother. And this moment of nostalgia for his past also reintroduces the theme of motherly love and ambition:

> SUSAN: I wanted to be a singer, I guess. That is, I didn't. My mother did. [...] It's just – well you know what mothers are like.
> KANE: Yes. You got a piano?[27]

This scene establishes the presence of the glass ball (which is later going to mean so much to Kane and to constitute the link with his past loss) on Susan's dressing table, to the lefthand side of her reflection in the mirror. Neither character draws attention to it, nor does the camera, but there it sits, like a narrative time bomb awaiting its moment, for the observant spectator to pick up and take note.

Patterns, symmetries and repetitions order the shape of the film, lying almost imperceptibly under the already complex flashback structure. First and foremost, these patterns confirm the film's ultimate control over its own sense, within which the investigator and the different narrators function like illusionistically handled marionettes. But the purpose behind the patterning is emotional as well as formal. Although the witnesses are unable to achieve any distance or understanding that can enlighten the Kane enigma, it is their engagement with his character that makes the film moving on an

immediate level. Repetitions create resonance, irony and pathos. For instance, Leland ends his narration with the story of his unfinished review of the disastrous *Salammbô* production. Kane finishes the review in the spirit in which Leland, before falling asleep over his typewriter and a bottle of whisky, had started it.

> BERNSTEIN: Mr Kane is finishing the notice the way you wanted it. I guess that'll show you.

The scene is played out in a three-way drama between Leland, Kane and Bernstein. The three, who formed an inseparable triumvirate in New York in the first section of the film, are meeting for the last time in Chicago. The scene and the sense of failure and ridiculousness that has overtaken Kane is heightened by the memory of Leland and Bernstein's presence when Kane wrote his 'Declaration of Principles' in the first half of the film. When, in Susan's narration, Leland returns the 'Declaration of Principles' torn up, along with his golden handshake, the ghost of the old, abandoned idealism hovers ironically over Susan's attempt to rebel against Kane's control. The scene ends with his shadow looming over her and darkening her frightened face.

There are three scenes between Kane and Thatcher. The third, which does not appear in the original screenplay, shows Kane forced by the 1929 recession to sell off assets to Thatcher. In certain visual and thematic ways it recalls the first scene between Thatcher and Mrs Kane. Then, Mrs Kane signed away her son to the banker; now Kane himself is signing away his newspapers to him. Before he signs, Kane walks far off into the cavernous office and stands under a high window. The composition, with Thatcher and Bernstein framing it in depth, is somehow reminiscent of Kane as a child playing in the snow, in the background of the shot in which his mother signs the agreement with Thatcher. During this scene, Kane says ironically:

> KANE: My mother should have chosen a less reliable banker.[28]

This rare mention of his mother seems to confirm the pattern of symmetry between the two scenes. And the repeated position of the characters draws attention to how often composition in depth is used to

frame Kane in a kind of isosceles triangle, at the apex of the looks of two other people.

Although *Citizen Kane* has a roughly symmetrical structure hidden under the chronological development of the Thompson interviews, one important scene breaks the chronology but adds another dimension to the symmetry: Thompson's first visit to Susan Alexander at the 'El Rancho' bar in Atlantic City. As she refuses to talk, and her part in the story only appears later, in its chronological order, this scene is anomalous. It also seems to break the symmetry that patterns the first section of the film around the public Kane, asserting himself in the male world of journalism and politics. In these terms, Susan belongs exclusively to the second section of the film. The scene is, apparently, yet another of the film's false starts.[29] However, Susan's presence at the beginning adds to the symmetrical resonances between the beginning and the end of the film. Her first appearance, although it has no narrative significance whatsoever, balances structurally with her final appearance, when she leaves Kane. The scene has, however, another structural function. By introducing Susan at the very beginning of the investigation, immediately before Thompson visits the Thatcher Library, the film juxtaposes, in a kind of montage effect, the male and the female strands in the narrative. The *mise-en-scène* sets up a polarisation between Susan and Thatcher, using iconography, connotation and material to suggest a comparison and an opposition between the two. Both scenes are introduced by an image of the character, a poster of Susan and a statue of Thatcher, in a parallel staging but with opposing emotional resonance.

Susan's image is first seen in close-up, a show-girl on a poster outside a bar. The image, made of plywood and paper, is impermanent. Her look, at the camera and over a bare shoulder, is provocative. The camera moves up to the roof and reveals the sign that announces her name and her appearance 'twice nightly' in the 'El Rancho' floor show. Even before the camera, with a crane shot that penetrates the skylight ceiling, discovers Susan, drunk and mourning Kane's death, the scene is resonant with the connotations of tawdry pathos and mock glamour. Thatcher also is first seen in image. His statue, a monument to a formidable and powerful man, is made out of marble, a lasting and expensive material. It proclaims not only his wealth but also his

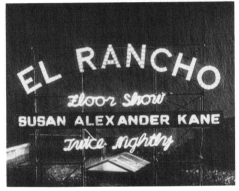

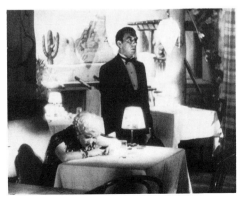

Susan at El Rancho

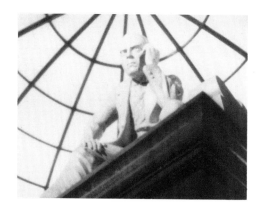

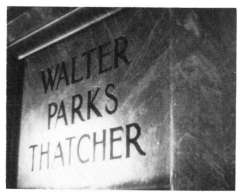

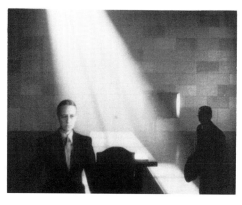

At the Thatcher library

standing in the world, as the camera reveals an inscription engraved in gold on the plinth, 'Walter Parks Thatcher', and the *mise-en-scène*, the music and the echoes in the sound suggest the connotations of grandeur and intimidation.

In the two scenes that follow these iconographical openings, the gender oppositions are continued in reverse. Susan is served by men. The bar's staff (John, the headwaiter, and Gino) are softly indulgent, bringing her a double highball when she refuses to speak to Thompson. The Thatcher Library, on the other hand, is under the authority of a woman without the slightest vestige of femininity, dressed in a severe suit and with an equally severe, repressive manner:

> Mr Thompson, you will be required to leave this room at four-thirty promptly. You will confine yourself, it is our understanding, to the chapter in Mr Thatcher's manuscript regarding Mr Kane.[30]

While the bar scene takes place at night, in diffused lighting, covered by the (permeable) glass skylight, Thompson visits the Library by day, and voices and footsteps echo round the marble hall. The Thatcher Library sets up multiple connotations of repression. It is like a bank, or a morgue, or indeed, as the door swings shut behind Thompson and into the face of the camera, like a prison. The paralleled *mise-en-scène* and the binary oppositions that suffuse these two scenes break the chronological unfolding of the film and set up a contrasted montage between them. The polarisation between Susan and Thatcher is like a threshold to the scene in which Thatcher takes Kane from his parents. It sets up a prefiguration of the later associations between that scene and Susan's glass snowstorm. But it also sets up a cross-gender association between Susan and Mr Kane, on a social and class level, in addition to the clearer, gendered, association between Kane's love for Susan and his love for his mother. The Thatcher flashback then covers, in three scenes, the whole span of Kane's career, from the first meeting in the snow, to Thatcher's rage at Kane's campaigns against capitalist corruption, to the Crash and Kane's bankruptcy. The last lines in the sequence are:

> THATCHER: What would you like to have been?
> KANE: Everything you hate.[31]

Thompson's first, unsuccessful, visit to Susan has a structural and not a narrative purpose in the film. The binary opposition between Susan and Thatcher sets up a formal premonition of the subsequent binary structure of the film.

. .

The scene of Kane's childhood separation from his parents in the snow presents in dramatic form the strands that dominate the later development of the plot and divide it into two main sections. This scene brings together the dramatic elements that will form the basis of the film's binary structure: the child's closeness to his mother, his instinctive aggression against his surrogate father, and the little sled that comes to stand for what was lost in the Oedipal triangle. The first, male-dominated, section of the film tells the story of the radical, Oedipal, Kane continuing to battle against his surrogate father. The second, Susan-dominated, section shows him isolated from public life and fetishistically amassing things, attempting to fill, as it were, the void of his first loss. When Kane, as an old man, gives his uncompromising answer to Thatcher's question ('everything you hate'), this one line suddenly illuminates the Oedipal element in his political behaviour. The line – the last line of the Thatcher episode – links back to the two previous scenes: Kane's violent reaction to Thatcher at their first meeting, and the *Inquirer*'s campaigns against everything Thatcher stands for. To fight against Thatcher, the banker and old-fashioned capitalist, Kane espouses the cause of those who suffer at the hands of privilege, using as his weapon a new form of capitalist enterprise: the mass circulation newspapers known in the United States as the 'yellow press'.

Kane's first attack on Thatcher with the sled is presented, visually and emotionally, as a response to an adult male who is threatening to separate him from his mother.

MOTHER: Mr Thatcher is going to take you on a trip with him tonight. You'll be leaving on Number Ten.
FATHER: That's the train with all the lights on it.
CHARLES: You goin', Mom?
THATCHER: Oh no. Your mother won't be going right away, Charles, but she'll...

CHARLES: Where'm I going?

FATHER: You're going to see Chicago and New York, and Washington maybe. Ain't he, Mr Thatcher?

THATCHER: He certainly is. I wish I were a little boy going on a trip like that for the first time.

CHARLES: Why aren't you comin' with us, Mom?[32]

The scene only makes sense from a psychoanalytic point of view. The characters' motivations and attitudes are not rational or explicable. They are deliberately inconsistent, and only the threat of the father's violence gives the scene cohesion. After Charles attacks Thatcher, his father says:

FATHER: I'm sorry, Mr Thatcher. What that kid needs is a good thrashing.

MOTHER: That's what you think, is it, Jim?

FATHER: Yes.

MOTHER: That's why ... [*holding Charles, music playing, snow falling*] ... he's going to be brought up where you can't get at him.[33]

This scene splits the image of the father into two opposed aspects, but both pose a threat to the child. While the biological father threatens the son with physical violence, the surrogate father threatens him with separation from his mother. The scene ends with mother and son clinging to each other, the mother protecting her child against his father's violence, the child holding on to her love and staring resentfully off-screen at his substitute father who proposes to introduce him to a new cultural and symbolic order. The child is suspended between two stages, on the threshold between a pre-Oedipal love for his mother and rivalry with his father and the post-Oedipal world in which he should take his place within society, by accepting the incest taboo and acknowledging the authority of his father. The scene is played with the irrationality and condensation of the unconscious; the characters act out their psychic roles without regard for verisimilitude, and the snow-covered landscape with its remote log cabin is an appropriate setting for this psychic moment. Kane never crosses the threshold between the

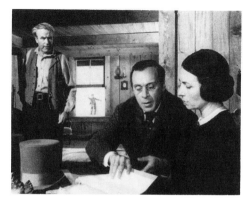

Kane's childhood separation from his parents

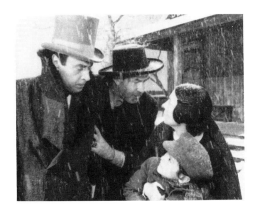

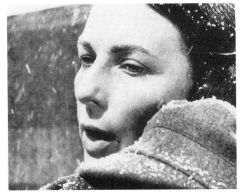

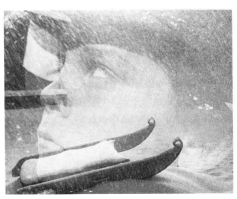

Kane's childhood separation from his parents (continued)

pre-Oedipal and the post-Oedipal, remaining frozen, as it were, at the point of separation from his mother and, from then on, directing his Oedipal aggression at his surrogate father.

This is the father who represents the demands of culture and society and disrupts the unity of mother and child. A child's closeness to its mother creates a sphere of physical and emotional completeness, simultaneously an Eden and a strangulation, a place of safety to escape from and, once escaped, a place of longing that cannot be regained. There is a before and an after. The sphere of maternal plenitude gradually gives way to social and cultural aspirations represented by the father's social and cultural significance. This process may never, as in the case of Charles Foster Kane, be satisfactorily achieved. If Mr Kane represents a pre-Oedipal father, Thatcher encapsulates the Oedipal father who should teach the child to understand symbolic systems on which social relations rest and which replaces the physical, unmediated bond between mother and child. Both money and the law are products of a social order based on abstract principles and symbolisation. Money transcends the physicality of a literal exchange of objects and substitutes an abstract system of value. The law transcends the literal and physical relations between people and places them within a timeless system of morality. The scene inside the log cabin polarises Kane's split father figures on each side of these symbolic systems. One represents poverty, failure and ignorance, the other represents wealth, success and education. When Mrs Kane signs her son away to the world of culture and social advancement, with a legal agreement and in return for money, she seems to acknowledge the inevitability of a transition that only the mother, she appears to say, can ever understand and only mourn.

The real father, who is left behind in the 'before' that the log cabin stands for, complains:

> FATHER: I don't hold with signing away my boy to any bank as guardeen just because ... we're a little uneducated.

His speech and dress are rough, and diametrically opposed to Thatcher, whose clipped legalistic language and dark suit come from a world without room for emotion. That world is about Order, in the sense both

of regulation and of hierarchy, without which money cannot become capitalism. Mrs Kane's grammatically correct speech and her dark dress are iconographically closer to Thatcher than to her husband. Agnes Moorhead's performance in this scene is moving precisely because of the emotion that she feels but contains. She understands some abstract cultural necessity while her husband ('I want you to stop all this nonsense, Jim'), in his naiveté, does not. The scene in the log cabin places Thatcher and Mrs Kane together on the righthand side of the frame, sitting at the table with the documents, while Mr Kane hovers anxiously, and unstably, across the left side. Charlie, in this famous scene of deep-focus photography, is playing outside, seen through the window, between the two sides. Within the Oedipal conflict, it is the mother's role to give up her child. To hold on to him would be to keep him in the nether world of infancy, cultural deprivation, impotence, and to prevent his departure on the journey towards greatness, towards the White House, as it were. In *Citizen Kane*, the transition is abrupt and painful. The small boy is taken from his parents and his home. He is, from then on, in conflict with the authority of the Symbolic Order.

The last shot of the scene holds for a long time on the abandoned sled, now covered by the snow, and a train's whistle sounds in the distance. In Freud's theory of the unconscious, a memory that is apparently forgotten is also preserved, to return, if called on, at a later date. The snow, with its connotations both of burying and of freezing, perfectly evokes this metaphor. The memory can be recovered when something happens to make the mind delve down into those depths of time and the unconscious, just as the memory of 'Rosebud' is revived for Kane by the little glass snowstorm and log cabin he finds when Susan leaves him. The *mise-en-scène* is no more rational than the character's actions. The remote snow-covered countryside and the little log cabin create a phantasmatic landscape which introduces American myth into the psychoanalytic metaphor, and the action combines melodramatic gesture with the rudimentary elements of Oedipal drama.

Hearst's own childhood had none of these mythological dimensions. However, Kane's campaigns against Thatcher and the Public Transit Company were drawn from Hearst's vendetta, which became a feature of the San Francisco *Examiner*, beginning in the late 1880s and continuing for many years, against the Southern Pacific

railway. This campaign provides the strongest grounds for the view of
Hearst as progressive and a defender of the interests of the people,
which Mankiewicz adopted as one side of the irreconcilable equation
underlying *Citizen Kane*. Hearst's campaign against Southern Pacific was
concentrated on Leland Stanford (whose name Hearst's columnist
Ambrose Bierce printed with sterling and dollar signs as initials).
Stanford was a close friend and colleague of Hearst's father, and both at
the time were Senators in Washington. This slight hint of Oedipal
conflict is transformed in the film into a significant psychoanalytic
theme. As Thatcher is both the object of his political aggression ('News
on the March': 'Walter P. Thatcher, grand old man of Wall Street, for
years the chief target of Kane Papers' attack on "trusts"') and his
guardian, the film sets up a psychoanalytic explanation for Kane's early
radicalism.

John Houseman says that Mankiewicz 'added overtones of
J. Pierpoint Morgan' to the otherwise fictional figure of Thatcher. The
Morgan dynasty represented the elite finance capital of Wall Street, the
transport capital of the New York Railroad and the industrial capital of
the Gary steel mills. The kind of journalism Hearst invented, the
sensationalist and jingoistic rhetoric of the yellow press, demanded
a mass circulation, working-class readership. W. A. Swanberg's
biography of Hearst describes the principles behind his relations with
his readership:

> He began publishing popular songs on Sundays – a real
> innovation – beginning with 'Ho! Molly Grogan', aimed at San
> Francisco's large Irish population. Since the city was strongly
> unionised, he reached out for the labour element with a column
> called 'The Workingman', devoted to the activities of the unions.
> … Above all [he sought] a smash front-page story every day that
> would startle, amaze or stupefy the reader and let him know he
> could depend on being startled, amazed or stupefied daily simply
> by buying the *Examiner*.[34]

The newspaper tycoons had a vested interest at stake in populist, anti-
elitist, anti-capitalist rhetoric. In Bernstein's narration, the *Inquirer*
evolves as a rhetorical weapon of populism out of two underlying

forces: the growth of yellow journalism as a discourse and cultural force that never hesitated to interfere in politics, and the effect that cut-throat competition for circulation had on the evolution of this particular journalistic gutter rhetoric. Bernstein's narration exemplifies the difficulty of character identification in *Citizen Kane*. The first part of his account deals with ('from before the beginning, young man') Kane's transformation of the *Inquirer* from a genteel journalism, written by the middle classes for the middle classes, into a mass circulation paper, directed at the working classes and immigrant populations, with a willingness to witch-hunt, fabricate, and play on the most vulgar and violent jingoistic sentiments to build up a readership. Kane is at his best here. Welles performs him with such engaging charm and energy that the audience almost accepts his egotistical amorality, especially as the old editor, Carter, the only opposing force, is played in such a way that the character cannot involve audience identification or even sympathy. This section is seen through Bernstein's adulating eyes. As a flagrant Kane 'yes man', he provides no distance from or perspective on the Kane/Carter conflict.

Kane's conflict with Carter is residually Oedipal. As the editor of the newspaper he is an older man in a position of authority who maintains responsible establishment values. While Kane denounces the Traction Trust to Thatcher's intense indignation, he also develops to Carter's intense indignation the sensationalist style and the exploitative methods that are the hallmark of the yellow press. Carter splutters in protest as Kane transforms the paper into the 'gossip of housewives'. Kane's yellow-press journalism is an affront to the values of an older generation either in its conservative capitalist or ineffectually middle-class form. Welles's characterisation of Kane plays up the youthful rebel, whose pleasure is in humiliating his elders, still in the spirit of his school and college days. Carter is easily disposed of, and the real conflict in this section of the film is between Charles Foster Kane and the shadowy, unmentioned Pulitzer figure at the *Chronicle*.

The *Chronicle* episode is based on Hearst's battle with Pulitzer's mass-circulation *World* after he ventured into the New York press scene with the small-circulation *Journal* in the mid-1890s. In the competition for circulation that followed, Hearst started by imitating the *World*'s scandal-sheet style and then poached the whole of the paper's Sunday

staff. When Hearst launched the *Journal* into a full-scale series of jingoistic fabrications, literally provoking the Spanish-American War, Pulitzer was forced to follow suit in order to protect his circulation. W. A. Swanberg comments in *Citizen Hearst*:

> The majority of the public found it more exciting to read about the murder of Cuban babies and the rape of Cuban women by Spaniards than to read conscientious accounts of complicated political problems and injustices on both sides. The hero-villain concept of the war was simple, easy to grasp and satisfying.[35]

During the party that celebrates the climax of the newspaper section of the movie, Leland hints that Kane's journalistic success contains seeds of moral decay, questioning both his wholesale acquisition, for a sum, of the *Chronicle*'s top editorial staff and the justification of pursuing the *Inquirer*'s war-mongering policies in Latin America. The shooting script includes dialogue in which Leland takes Kane to task for the Cuban affair. He answers:

> KANE: Jed, how would the *Inquirer* look with no news about this non-existent war with Pulitzer and Hearst devoting twenty columns a day to it. ... The *Inquirer* is probably too one-sided about this Cuban thing – me being a warmonger and all. How's about your writing a piece every day – while I'm away – saying exactly what you think. (Ruefully) Just the way you say it to me, unless I see you coming.

This scene takes place in a brothel, to which the party has moved as Kane attempts to assuage Leland's anxieties and distract him with girls. It therefore had to be cut after the script had been submitted to the Hays office. In the original, Kane, in a characteristically quixotic change of mood, suddenly says:

> KANE: Come to think of it, Mr Bernstein, I don't blame Mr Leland for not wanting to be a war correspondent. It isn't much of a war. Besides, they tell me there isn't a decent restaurant on the whole island.[36]

The loss of this dialogue leaves an unadulterated opportunistic Kane in the screen version.

The party scene celebrates the *Inquirer*'s coming of age. It also celebrates the last moment of Kane's youth. The father figures who stood in his way (Thatcher, Carter and the *Chronicle*) have been defeated by the Kane *Inquirer*. For Kane himself, and for those closest to him, a triumphant happy end seems to be a foregone conclusion. Happy endings should, in traditional and popular culture, be immediately preceded by marriage, the rite of passage that marks a transition from youthful irresponsibility to patriarchal authority. The very next scene after the party introduces Kane's engagement and, when he then appears with Emily, Bernstein's narration ends on a triumphant note. He understands that Kane's marriage opens the way for his next step up the ladder towards the Presidency.

Citizen Kane suggests a psychoanalytic, Oedipal answer to Mankiewicz's reflection on the gap between Hearst's early radical politics and his later right-wing sympathies. From the point of view of the completely different radicalism of the New Deal, this kind of subjective, personalised attitude to politics is both reminiscent of the radical rhetoric of fascism and an indictment of the previous generation of American politicians. Kane's politics are presented throughout the film as an extension of his newspapers, as inflated rhetoric, buoyed up by personal denunciation. There is no substance to his 'Declaration of Principles', and 'the cause of reform' is a smoke-screen for his own political ambitions. Kane's radicalism, as an Oedipal radicalism, a conflict between generations rather than principles, points to a further split between different types of capitalism, a conflict between banking interests which represent only an elite and those of communications which have to find a populist appeal outside the narrow limits of the capitalist class. Even stripped of its Oedipal element, the split is a product of an internal contradiction rather than disinterested political consciousness. When Mrs Kane sacrificed her love for her son, and his love for her, on the altar of banking capitalism, she created a hybrid, a creature who will be neither fish nor fowl, a man who wields enormous cultural and political power but is bound to struggle against authority. This split, which Kane himself articulates clearly, is the source of his success as a newspaper tycoon and his downfall as a politician. While

he can hate the establishment effectively he cannot join it, unless he can encapsulate the whole system into his own person. The success of the *Inquirer* and protofascist politics, *Citizen Kane* seems to suggest, are two sides of the same coin. The closer Kane moves to the centre of power, the further he moves from any vestiges of idealism, while at the same time he undermines his own narrative trajectory towards patriarchal authority and the symbolic order.

It is, of course, rather patronising to link a recognisable public figure's success and failure to his unconscious, and the clichéd nature of Kane's psychoanalytic traits aggravate this sense of a demeaning invasion of privacy. On the other hand, any attempt, however first-stage, to make connections between the national psyche and irrational politics in terms both of class and of the traumatic experience of immigration is an extremely daring and fascinating enterprise. Although the real-life Hearst's concern with the working man may have been primarily based on the need to build up a mass circulation newspaper, the screen Kane creates a weapon to fight the vested interests of his guardian and forges a link back to the interests of his non-Symbolic father. But in the last resort, he is incapable of understanding the realities of class politics or of creating a political discourse beyond that of the yellow press and his own personal power.

. .

If Kane's childhood trauma embellishes Hearst's politics with a fictional unconscious, its *mise-en-scène*, the log cabin, embellishes the psychoanalytic motif with American mythology. Hearst, too, aspired to the White House, through the Governorship of New York State. His political career was divided between years of stage-managing intricate machiavellian machinations with the Tammany Hall political machine in New York, and running for public office himself. There were two flaws that would set back and finally finish off his political career. First, his wild, opportunistic denunciations of the Tammany 'bosses', including a cartoon of Charles Murphy as a convict in Sing-Sing, failed to conceal the fact that no one really knew if he was in their pocket or they were in his. This battle came to an abrupt end when Al Smith took a principled line and refused to share a ticket with Hearst, after too long being the subject of vociferous Hearstian denunciation and behind-the-

scenes machination. Secondly, Hearst was haunted by the rhetorical excesses of his own papers. His unscrupulous and savage attacks on public figures had no regard for truth or balance, and he never lived down the popular opinion that the Hearst papers' campaign against President McKinley had triggered his assassination. Although there were, after his liaison with Marion Davies, hints about his private morals, his political life was not finished by scandal. On the other hand, had he persisted in his ambition for the Presidency, it might have been. But there was never any doubt that Hearst came from an established family, the son of a successful businessman who was also a Senator. Kane's humble origins in a log cabin take the story beyond its own singularity to evoke a favourite legend of simplicity and opportunity in the New World.

Kane's campaign as independent candidate for Governor of New York is generally acknowledged to be a stepping stone on his way to the Presidency. And the image of the White House complements the iconography of his childhood home. In his trajectory from the poverty and obscurity of a remote Colorado log cabin to one step from the White House, Kane encapsulates a populist cliché of the American political dream. Like a version of the old, Whittingtonesque folk-tale of trans-class mobility, it is a story-cum-icon of American mythology. James Thayer called his biography of President James Garfield *From Log Cabin to White House* to emphasise the parallels between Garfield and President Lincoln, both born to poor pioneer families 'in the wilderness', both called to the highest office in the United States. The United States, as the land of equality and opportunity, promised to put the old folk-tale fantasy within the actual reach of the European rural and urban poor who crossed the Atlantic. Freud considered the story of a young man's journey to seek his fortune to be the basic daydream, but he also points out that it integrates an erotic fantasy with the ambitious fantasy. The young man achieves power and/or riches through marriage to the daughter of an important man who will pass on his position to a worthy son-in-law.

Kane's first marriage illustrates the close ties between the erotic element of this daydream story and the theme of inheritance. His engagement and marriage to Emily Monroe Norton, the President's niece, puts him, as it were, in line to succeed the President, just as, in

Freud's bourgeois version, a father-in-law leaves a business to his daughter's husband or, in the folk-tale version, the hero is rewarded for his heroism with the princess's hand in marriage and inherits her father's kingdom. Bernstein's narration, which charts Kane's upward rise, climaxes with the party, and then, almost like an acknowledgment of the narrative conventions of the daydream/folk-tale, ends with Kane's engagement.

> MISS TOWNSEND (awestruck): Emily Monroe Norton, she's the
> niece of the President of the United States!
> BERNSTEIN: President's niece, huh! Before he's through, she'll be
> a President's wife![37]

At the party, even without the censored brothel scene, the chorus girls introduce a sexual, female presence into the story for the first time. Scenes of an orgy in Rome in early versions of the script were eliminated and thus make this transition particularly pointed. Coming just before the announcement of his marriage (in film time, that is, rather than story time) the party celebrates the end of Kane's bachelor days in the spirit of a stag night. Kane dances with the girls, sometimes seen between Leland and Bernstein as they talk, sometimes reflected in the window, sometimes fully on screen. The editing of this sequence, the combination of deep space and montage, is a *tour de force*, and there is nothing like it in the rest of the film. Cuts on movement mesh with the rhythm of the song: as, for instance, one of the girls pushes Kane away from a kiss, the cut rhymes her movement with that of a stream of cigar smoke as Leland exhales.

The *Inquirer* and its campaigns fall into the background when Kane wins the circulation battle and turns to the political battlefield. In the sixteen years covered by the breakfast-table montage, the fairy-tale promises of Bernstein's narration fade away. The film and Kane's life then both reach a crossroads. He is poised to make his move to the White House. By the time he starts on his political campaign, Kane's radical, populist politics are a thing of the past and slogans about the 'cause of reform' against Tammany Hall look increasingly like an investment in his own personal power. Both Leland, explicitly, and 'Boss' Gettys, implicitly, accuse him of not being able to distinguish

between the personal and the political. Kane conducts his political campaign in the form of a savage personal attack, which goes beyond the accepted norms of political exchange and rebounds back into his own personal life. He claims that no scandalous revelation can 'take the love of the people of this state away from me'. And the final break with Leland is over his increasingly personalised and authoritarian concept of politics. In the original shooting script the dialogue went like this:

> LELAND: Charlie, why can't you get to look at things less personally? Everything doesn't have to be between you and – the personal note doesn't always –
> KANE (violently): The personal note is all there is to it. It's all there ever is to it. It's all there ever is to anything! ... – the right of the American people to their own country is not an academic issue, Jed, that you debate – and then the judges retire to return a verdict – and the winners give a dinner for the losers.[38]

As Leland sees it, Kane's populism has become personalism. This exchange was not included in the final film. The underlying theme of protofascism had also been more explicit, of course, when Kane's son had grown up to be a Nazi in an early version of the script.

From a structural point of view, Leland's function as Kane's conscience allows him also to jolt the film's memory, as, for instance, he returns the 'Declaration of Principles'. Leland's criticism of Kane's politics brings with it an echo of Kane's own earlier speech of self-justification, to Thatcher.

> LELAND: You used to write an awful lot about the working man. ... He's turning into something called organized labor. You're not going to like that one little bit when you find out it means your workingman expects something as his right and not your gift. Charlie, when your precious underprivileged really get together, oh, boy, that's going to add up to something bigger than your privilege. ...[39]

Kane's words had been these:

> KANE: On the other hand I am also the publisher of the *Inquirer*.

As such it is my duty – I'll let you in on a secret – it is also my pleasure – to see to it that the decent, hard-working people of this community aren't robbed blind by a pack of money-mad pirates just because – they haven't anybody to look after their interests.

I'll let you in on another little secret, Mr Thatcher, I think I'm the man to do it. You see, I have money and property. If I don't look after the interests of the underprivileged maybe somebody else will – maybe somebody without any money or property.[40]

Kane's struggle against Thatcher might supply the grounds for his principled attack on capitalism, but its Oedipal aspect flows over on to his struggle against Gettys and organised labour. Gettys, the last of the male figures he defies, confuses Kane's ambitious and emotional life by his attempted blackmail. When he forces Kane to choose between Emily and Susan, he resurrects the division between Thatcher, as representative of the father's symbolic order, and Mrs Kane, as representative of emotion. Emily was always integrated into Kane's public life and had been the sign of his political ambition. Susan, on the other hand, was associated from the first with his mother. Kane holds on desperately, when faced with a repeated loss, both to Susan and to his fantasy of 'the love of the people of this state'. And when he loses the election, he then grasps her like a precious object that can fill the void which opened up at the moment he was separated from his mother. This is the moment when his trajectory towards the White House ('News on the March': 'The White House one easy step...') is derailed and diverted towards the lonesome grandeur of his palace, 'Xanadu'. Rather than a story of all-American success in the progress from log cabin to White House, the story tells of a trajectory from log cabin to 'Xanadu', which ends in isolation, out of touch with the course of American politics, history and destiny.

...........................

While the Leland narration takes Kane through his nemesis, his first moments of doubt had been expressed earlier during the party in Bernstein's narration. This is the moment when Kane's collecting mania

is first mentioned. The symptom of his future appears before his relationship with Susan and subsequent self-exile away from the male world of power and politics into the female world of fantasy and fetishism. Bernstein mentions Kane's new habit of collecting statues:

> BERNSTEIN: Say, Mr Kane, so long as you're promising, there's a lot of pictures and statues in Europe you ain't bought yet –
> KANE: You can't blame me, Mr Bernstein. They've been making statues for two thousand years and I've only been buying for five.[41]

The shooting script adds the following comment:

> BERNSTEIN: Nine Venuses already we got, twenty-six Virgins – two whole warehouses full of stuff – promise me, Mr Kane.[42]

Bernstein not only introduces Kane's mania for collecting European art work, he also draws attention to the fact that the collection is female. Bernstein reiterates his connection between Kane's collecting and the feminine in the following dialogue, when he shows Leland Kane's telegram asking for the largest diamond in the world. Leland is surrounded by statues and is in the process of unpacking yet another crate. In spite of the long time-elapse, Leland links this scene to the previous one by humming the 'Charlie Kane' song:

> LELAND: I didn't know Charlie was collecting diamonds.
> BERNSTEIN: He ain't. He's collecting somebody that's collecting diamonds. Anyway – he ain't only collecting statues.[43]

Collecting was a well-known habit of Hearst's, said to have its origin in his first European tour as a child, when his mother took him to the Louvre and he wanted to buy it. But, yet again, the film introduces a psychoanalytic motif to connect Kane's collecting obsession with his rebellion against the frugal principles of careful investment and return that Thatcher stands for. The third, and last, scene between Kane and Thatcher (which is in the film but not in the original script) includes this dialogue:

THATCHER: Yes, but your methods. You know, Charles, you never made a single investment. You always used money to –
KANE: To buy things. My mother should have chosen a less reliable banker.[44]

The 'Protestant ethic' of productive capitalism and the wasteful consumption of capital through the accumulation of useless things stand in diametrical opposition to each other. Kane is not interested in productive capital ('Sorry, but I'm not interested in goldmines, oil wells, shipping, or real estate...') and the abstract, symbolic, concepts of money and exchange. He cashes in his capital and turns it into concrete objects. In the second part of the film, and especially around the construction of Xanadu, Kane takes spending to obsessive levels, unable even to unpack the vast amount of stuff he accumulates. At the same time, evidenced in the last scene at Xanadu, he has never thrown any object away. The 'things' of a lifetime lie strewn about, higgledy-piggledy, and the camera tracks across them to find the original object, the sled 'Rosebud'.

Leland surrounded by statues

Welles was always quite happy to allow that Mankiewicz had come up with the 'gimmick' of 'Rosebud'. Pauline Kael points out that he referred to it as 'dollar book Freud'. However, according to Brady, Welles's comment on his own psychoanalytic interpretation of *Citizen Kane* went like this: 'I admit it's dollar-book Freud, but nevertheless that's how I understand the film.'[45] (See also the Appendix.) I have been arguing that the psychoanalytic dimensions of the film go way beyond the 'Rosebud' enigma. However, there are ways in which 'Rosebud', as an object, performs an important function in linking together the film's complex themes about obsessive accumulation of 'things'. The sled marks the memory of Kane's separation from his mother, and that memory returns when Susan leaves him. *Citizen Kane* works around connections between objects that forge chains of meaning which link through the film. Just as statues are a central obsession of Kane's, so the film itself gives special status to objects and objectifications.

The system of objects works on different levels: from the aesthetic qualities of the film, its semiotics and its *mise-en-scène*, to the 'Rosebud' enigma, to Kane's objectification of Susan, to the antagonistic relation between productive capital and fetishistic consumption. At his death scene, Kane's association between the glass ball and the word 'Rosebud' is not supplied to the audience, and sets up a semiotic riddle which will not be resolved until the end. The logical link between two associated objects, the glass ball and the sled, is missing. The only clue is the word. There are two signifiers, a name ('Rosebud') and a symptom (a fetishistic attachment to the landscape contained in the glass ball), with no signified supplying a coherent link between the two. It is not, of course, until the very end of the film that the signified, the little sled, is supplied to the audience and the psychic and semiotic enigma is resolved. Then it is possible to look back, through the text, and link together the chain of symptoms that have dominated the second section of the film. Kane's relationship with Susan is the crucial missing link in the chain.

It has always been clear that Susan Alexander had little in common with Hearst's mistress, Marion Davies, with whom he fell in love when she was performing at the Ziegfeld Follies and whom he later made into a movie star. Although Xanadu is a direct reference to

San Simeon, they lived there together happily, only leaving in 1947 on account of Hearst's worsening health. Marion Davies's screen career went into abeyance after the coming of sound, but she had been a witty and talented performer. There was no gaping gulf between her patron's promotion of her and her abilities. In *Citizen Kane*, Susan Alexander turns out to be, in Jed Leland's words, 'a pretty but hopelessly incompetent amateur', and at this point the film introduces a central symptom of fetishism. Welles constantly emphasised the minimal nature of the Hearst model for Kane, but particularly vociferously when it came to Marion Davies. He said in his introduction to her book, *The Times We Had*: 'Xanadu was a lonely fortress and Susan was quite right to escape from it ... [Marion Davies] was never one of Hearst's possessions and she was the precious treasure of his heart for more than thirty years until his last breath of life. Theirs is truly a love story. Love is not the subject of *Citizen Kane*.' And then he adds: 'If San Simeon hadn't existed the authors would have had to invent it.'[46]

I argued earlier that the film does not use a voyeuristic cinematic style to portray Susan. She is never constructed into an object of desire for the spectator. One important reason for this is that the audience has to be separated from Kane's point of view when it comes to Susan's erotic qualities and performing abilities. Kane's estimation of his loved object is wildly at odds with reality. In the first section of the movie, the audience is carried along on the wave of Kane's success and his struggle against Thatcher, and caught by Welles's powerful charm. In the second part, once Kane's energy and ambition are diverted to Susan, the audience loses any identification it might have found in its central character. From the first moment that Susan sings at the parlour piano, audience reaction is similar to that of the two stage-hands in the opera when, with a long movement upwards, extended by special effects, the camera finds the two men and one of them simply holds his nose. Susan's singing stinks. But for Kane, her voice is the source of true fascination. Along with his judgment, Kane loses his wit, his cynicism, his sophistication and all the other qualities he had acquired from being thrown out of the best schools in the United States and running a couple of newspapers. As he fetishises Susan's inadequate voice into a precious and valued object, he blinds himself to what he knows and invests all his emotional and financial resources in a deluded belief.

While the film never turns Susan into an object of desire for the spectator, during the scene of their first meeting it changes style to depict the attraction between her and Kane. This is the only scene in which close-ups and shot/counter-shot editing dominate. They look at each other and, as they talk, the film cuts from one to the other, and a slightly gauzy effect is added to the image, out of keeping with its usual sharp-edged, contrasty style. An electric current flows through their very ordinary conversational exchange so that the tone of their voices and the softness of their looks, cut to create a rhythm between voice and look, build up into a very charged erotic exchange. Susan had looked back over her shoulder at the crossroads and invited Kane up to her room in a voice and with a look of sexual invitation. Her voice is quiet, unaffected and modulated, and in complete contrast to her high-pitched screechiness later on. And then, once she is all he has left, in a complete reversal of the unaffected, implicitly sexual simplicity that first attracts him, Kane has Susan transformed into a highly stylised and produced object in the opera. As spectacle, attempting to impersonate the erotic codes essential for woman as spectacle, she knows she fails. With her

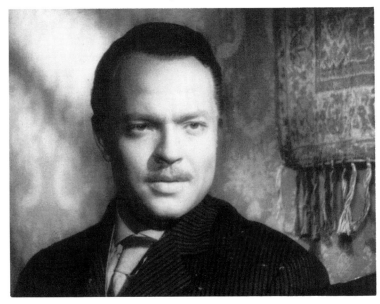

Kane and Susan: a charged erotic exchange of looks

small, inadequate singing voice, she is embellished with an elaborate costume and crowned with two enormous blond plaits, which are not only incongruous to her personality but add to the cultural confusion that surrounds the opera. All Susan's singing is given a European veneer. The opera sequences are created out of operatic pastiche, just as Xanadu is built out of a pastiche of European architecture. John Houseman says:

> It was during my last three days in California that I made my final contribution to *Citizen Kane*. Bernard Herrmann had arrived from New York to work on the score, including the opera in which Susan makes her ill-fated debut at the opera house her husband had built for her. Benny had decided not to use a scene from a standard opera but to create one of his own. He decided it should be a French opera and asked me to write him a text. Remembering my father's bathroom recitations, I hurriedly assembled a potpourri from Racine's *Athalie* with some added lines from *Phèdre*. It did not make any sense; as sung, slightly off

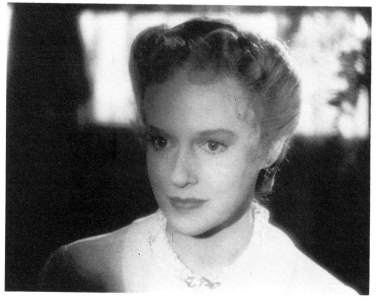

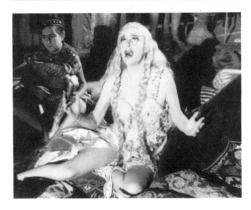

Susan in the opera

key by an unknown soprano, lip-synched by Dorothy Comingore, it was barely intelligible; but around it Orson built one of the great visual sequences of his film.[47]

The rehearsal of the opera carries confusion of culture into an elaborate confusion of action, swirling around Susan. The opening, in Chicago, actualises the separation between Kane's investment in Susan and everyone else's estimation of her. The scene is intercut between the bored audience, Bernstein dozing off, Leland tearing his programme into strips, and Kane himself, intently watching, alone in his private box in the opera house he had built for her performance. It is as though he had set up a private voyeuristic scenario, monumentally costly and elaborate, in which his fetishised object performed for him alone while he simultaneously displayed her to the world. And his lack of distance ('We're going to be a great opera star') is confirmed when he says: 'You will continue with your singing, Susan. I don't propose to be made ridiculous.' After her suicide attempt he constructs another monumental setting, a mausoleum to preserve her in a living death, for his fantasy scenario.

At the same time, the review Kane finishes for Leland indicates that, in some way, he knows. Freud, in his short essay 'Fetishism',[48] discusses the mind's ability to separate knowledge and belief. Out of this perverse refusal of socially accepted value, a worthless object is elevated to the status of cult. For Freud, fetishism is a symptom of an unconscious disavowal, and is also closely associated with the mother. The fetishised object protects the psyche from something that it cannot acknowledge, which Freud considered to be a traumatic awareness that the sign of sexual difference was that the female lacked a penis. Psychoanalytic theorists have since argued that fetishism is a structure of which the castration model need only be one example; fetishistic substitution can result from other kinds of traumatic loss. In the Kane 'case study', the child's separation from his mother is traumatic and need not be literally or mechanically tied to castration anxiety. Within the concept of infantile loss, the lost objects that signify loss easily either merge into one another or carry their affect across from object to object.

The Oedipal drama is narrative. It brings conflict, desire, and then

resolution. It takes the male child away from his mother's apron strings and promises him his father's future, if, in the meantime, he obeys his father's law and order. Fetishism, on the other hand, holds time in check. It is fixated on a thing which artificially resists the changes that knowledge brings with it. The fetish is the legacy of some single, traumatic moment in time, which then remains frozen in the unconscious mind, and the trauma transmutes into an obsession with an object. The object links back to the original scene and substitutes for it. Freud argues that the fetish functions as a screen memory. The fetish, preferably glittering, dazzling, attracting and holding the eye, interjects an object between memory and the original traumatic moment. At the same time, the object also marks the place of the lost memory it masks. Freud describes a screen memory as: 'a witness, simultaneously precious and insignificant, where something that must never be lost may be hidden and preserved.'

A thing that is substituted for another, even in imagination or in the unconscious, comes to stand for the thing it replaced, and the representation marks the lost presence of the original thing, now preserved only by a memorial or sign. But in the case of fetishism, the sign, the thing, also has to displace its link with what it meant; it is the mark of a meaning that cannot be contemplated and is disguised or veiled by an over-valuation of the substitute object. As soon as one thing is put in the place of another, a sign is set up that replaces the previous, literal reality. It refers back to the original object but its meaning has to be interpreted to be understood. If the link is lost, the signifier becomes an enigma, an object of curiosity to be deciphered, like a hieroglyph or a rebus. On the other hand, it might proliferate its meanings through metaphor, double entendres, puns or even misunderstandings.

These psychoanalytic and semiotic theories illuminate the way in which objects in *Citizen Kane* function as signs that weave the themes of the film into the texture of a rebus. Kane's mania for collecting things and his inability to throw anything away seem to be an attempt to retain the memory of a lost object which itself stood for a lost state of being. Kane's collecting is associated with his first journey to Europe and is directed, mainly but not exclusively, towards European things. The statues are a first symptomatic expression of this fetishistic obsession.

They prefigure the opera, in which Susan is transformed into a performing automaton attempting only to reproduce mechanically and inadequately the sounds and gestures programmed into her. Then both, the things and the scenario for Susan, are concentrated in Xanadu itself; the opera, the objects and the castle, while being constructed out of culture, end up as cultural pastiches. While having a veneer of European antiquity and culture, they are empty, shell-like constructions which Kane only accumulates and never even attempts to understand.

The image of Kane at the end of the film is like an allegorical warning about the fate of European/American relations. As I said, the film was made during the bleakest period of the war when Roosevelt was becoming more and more convinced of the need for American intervention. Traditional American isolationism was fighting a rearguard action against the President's desired foreign policy, and it seems clear that it was only something like the bombing of Pearl Harbor that could unite the country in support of the war. Welles's portrayal of Kane is an apt image of the destiny that isolationism would bring in its wake. He is shown as an old man, lonely and alone, isolated in the enormous, claustrophobic castle he has constructed as a fantasy world against the world outside, incarcerated inside his own mausoleum. This image seems to suggest the isolationist policies of the Hearst press; and Xanadu, through its blatant similarity to San Simeon, is one of the most transparent references to Hearst in the film. The commentary in 'News on the March' describes it:

VOICE-OVER: Paintings, pictures, statues, the very stones of many another palace. Enough for ten museums. The loot of the world.

Robert Carringer analyses the RKO art director Perry Ferguson's designs for Xanadu, showing how the Great Hall was based closely on a photograph of the Great Hall at San Simeon, and traces the architectural features of the castle to the architectural files kept in the RKO art department. He says: 'The Hearstian element is brought out in the almost perverse juxtaposition of incongruous architectural styles and motifs – Gothic along the far wall, Venetian Baroque in the loggia, Egyptian on the landing (including a sphinx on a plinth!), vaguely far

Eastern along the staircase.'[49] Such a confusion of cultural motifs and epochs points to a confusion about history and the ordering of time. If Kane is unable to understand or acknowledge either the processes of history or his own place within and subordinated to a cultural system that extends beyond his own personal control, then he comes close to personifying the idea that reactionary tendencies in the United States itself were characterised by these traits. But through its pseudo-biographical format, its fusion of a fictional unconscious on to a typical and historical figure, the film implies that the inability to order history and culture may be a symptom of a repressed but traumatic loss. The film is implying that the bonds between the United States and Europe are not personal and sentimental but a matter of historical and political responsibility, and have to be analysed and articulated. A failure to do so would be equivalent to the withdrawal of the wealthiest nation in the world into a state outside the social and the historical. And, also by implication, the isolationist stance is a sign of an unworked through Oedipal trajectory that has been prematurely broken off, leaving the

The great hall at Xanadu

subject tied to a 'frozen' memory of loss and the repression of history.

To many Americans in the period of *Citizen Kane*, Europe represented the 'before' in their or their immediate family's personal history. It was antiquity, the place of ancient origin, the 'old world'. It is striking that no Hollywood genre and extremely few individual films deal with migration across the Atlantic. It is almost as if this passage was a taboo subject in American popular culture. From a Freudian viewpoint, antiquity, the old world, supplies a metaphor for the formative 'before' in the before/after divide between the mother's exclusive, dependable love and a child's journey into the outside world of independent subjectivity. In Kane, however, the old world is presented ambivalently. It also contains a threat of paternal violence, which the mother uses as a rationale for separating herself from her child. A child, taken from the continuity of his historic relationship with his mother and propelled headlong into a 'new world', evokes the immigrant's contradictory emotions of liberation and nostalgia. A sense of loss may linger, to be covered over by forgetting the past, and made good both through the freedom offered by the American Dream and the promise of 'things' offered by the democracy of consumer commodities.

The papers known as the 'yellow press', the Hearst and Pulitzer newspaper empires, could initiate new Americans into their new language and way of life while providing cheap, simple entertainment with stories of sex and violence in a style similar to that of the old popular broadsheets in Europe. The 1890s, when the fictional Kane turns the *Inquirer* into a mass circulation paper, was a turning-point, melting-pot decade for the United States. Millions of immigrants, mainly Italians, Germans and Russians, were pouring across the Atlantic into a country gripped by severe recession. It was during this period that the real-life Hearst left his Californian springboard, the San Francisco *Examiner*, and with his New York *Journal* ventured into competition for the East Coast popular press market.

In the bitter battle for circulation that followed, Hearst built up the *Journal* through a hysterical campaign against the Spanish in Cuba. In reality, 'there was no war in Cuba'. But moments of extreme internal social and economic crisis call out for the external distraction of war, which succeeds in uniting a fragmented people around slogans, nationalism and xenophobia rather than their own dire realities. And

Hearst's stand implicitly pointed towards a Latin America in which European controlling interests would soon be replaced by North American ones. Newly liberated from old-world domination, this new Latin America could provide a first base, a springboard, for an American economic expansion that Hearst would never have seen as imperialism. Two of *Citizen Kane*'s most powerful images seem to conjure up the relations between Europe and the United States. First, the poverty-stricken cottage of an 'old world', simultaneously lost and preserved in a frozen landscape, where the child leaves his home and embarks on his journey to riches, and, secondly, the huge brooding figure of Kane, an icon of American capitalism, isolated in his fantasy castle built out of the loot of Europe.

Kane's politics are as confused as his culture. 'News on the March' juxtaposes Thatcher's denunciation of Kane as 'a communist' with a soap-box speaker's denunciation of him as 'a fascist'. Kane describes himself as 'an American', implying perhaps that the rhetoric of the new nation stands outside the old-world struggles between left and right. The Bernstein sequence shows the tactics by which Kane transforms the *Inquirer* into Hearstian yellow journalism on the model of the *Chronicle*:

> KANE: Mr Carter, if the headline is big enough it makes the news big enough.

And:

> KANE: If Mr Silverstone gets suspicious and asks to see your man's badge your man is to get indignant and call Mr Silverstone an anarchist. Loudly ... so the neighbours can hear.[50]

This scene is immediately followed by Kane's 'Declaration of Principles'. These principles are closely modelled on a declaration of Hearst's, and expose the inconsistency and hypocrisy of yellow-press radicalism. By the time Kane is launched into his political campaign, his words about 'the underprivileged, the underpaid, and the underfed' are spoken over images of his own top-hatted, black-coated supporters. The 'people' are not in evidence. The virulent opposition with which

politicians of the previous generation had received the New Deal graphically illustrated the empty rhetoric of Hearst's claim to represent 'the people'. When it came to paying taxes to support social legislation or recognising unions in his companies, Hearst started to cry communism. If Orson Welles feared that opposition to the war in Europe could bring about Roosevelt's downfall, he used *Citizen Kane* to remind people of the alternative. And if isolationist policies in America were to lead to a victory for fascism in Europe, *Citizen Kane* pointed to the confusion endemic in pre-New Deal politics, and the difficulty of understanding history for a people who had exchanged the Old for a New World.

. .

Orson Welles evolved a cinematic and narrative style for *Citizen Kane* that appeals to people to decipher the images and implied messages in front of them, in their own right. And the film's own structure directs the spectator to take a second look, with hindsight and detached from the linear unfolding of the surface of a story. The second look may make visible what it is that Kane has repressed in his history, retreating into belief from knowledge, and, on another level, this second look may make visible the knowledge that has evaded the investigator who is stuck with the surface of things. And, allegorically, the spectator's look back at the film may lead to a wider reflection on history and to an inquisitive look at political rhetoric in which repression of knowledge and apotheosis of spectacle mutually reinforce each other.

APPENDIX
. .

Orson Welles's statement to the press on the subject of whether *Citizen Kane* was based on William Randolph Hearst.

I wished to make a motion picture which was not a narrative of action so much as an examination of character. For this, I desired a man of many sides and many aspects. It was my idea to show that six or more people could have as many widely divergent opinions concerning the nature of a single personality. Clearly such a notion could not be worked out if it would apply to an ordinary American citizen.

I immediately decided that my character should be a public man – an extremely public man – an extremely important one. I then decided that I would like to convince my audience of the reality of this man by means of an apparently legitimate news digest short concerning his career. It was of the essence of my idea that the audience should be fully conversant with the outlines of the public career of this fictitious character before I proceeded to examine his private life. I did not wish to make a picture about his public life. I wished to make a picture about the backstairs aspect of it. The varying opinions concerning his character would throw light on important moments in his career. I wished him to be an American, since I wished to make him an American president. Deciding against this, I could find no other position in public life beside that of a newspaper publisher in which a man of enormous wealth exercises what might be called real power in a democracy. It is possible to show how a powerful industrialist is potent in certain phases of government. It is possible to show how he can be good and bad according to the viewpoint of whoever is discussing him, but no industrialist can ever achieve in a democratic government the kind of general and catholic power with which I wished to invest my particular character. The only solution seemed to place my man in charge of some important channel of communication – radio or newspaper. It was essential for the plot of the story that my character (Kane) live to a great age, but be dead at the commencement of the narrative. This immediately precluded radio. There was no other solution except to make Kane a newspaper publisher – the owner of a great chain of newspapers. It was needful that Kane himself represent new ideas in his

field. The history of the newspaper business obviously demanded that Kane be what is generally referred to as a yellow journalist.

There have been many motion pictures and novels rigorously obeying the formula of the 'success story'. I wished to do something quite different. I wished to make a picture which might be called a 'failure story'. I did not wish to portray a ruthless and gifted industrialist working his way up from a simple lumberman or street car conductor to a position of wealth and prominence. The interpretations of such a character by his intimates were too obvious for my purpose. I therefore invested my character with sixty million dollars at the age of eight so that there was no considerable or important gain in point of wealth possible from a dramatic point of view. My story was not, therefore, about how a man gets money, but what he does with his money – not when he gets old – but throughout his entire career. A man who has money and doesn't have to concern himself with making more, naturally wishes to use it for the exercise of power. There are many, of course, in 'real life' who are exceptions to this, but the assumption of flair and vigor on the part of Kane as a personality made such an inclination obvious in his makeup. It was also much better for the purpose of my narrative since the facts about a philanthropist would not make as good a picture as a picture about a man interested in imposing his will upon the will of his fellow countrymen.

If I had determined to make a motion picture about the life of a great manufacturer of automobiles, I should have found not long after I started writing it that my invention occasionally paralleled history itself. The same is true in the case of my fictitious publisher. He was a yellow journalist. He was functioning as such in the great early days of the development of yellow journalism. Self-evidently, it was impossible for me to ignore American history. I declined to fabricate an impossible or psychologically untrue reaction to American historical events by an American yellow journalist. The reactions of American yellow journalists – indeed all possible publishers – to wars, social injustices, etc., etc., were for a great period of time in the history of these matters identical. Some have identified their names with certain events, but all are concerned with them. My character could not very well disregard them. My picture could not begin the career of such a man in 1890 and take it to 1940 without presenting the man with the same problems

which presented themselves to his equivalents in real life. *His dealings with these events were determined by dramaturgical and psychological laws which I recognize to be absolute. They were not colored by the facts in history. The facts in history were actually determined by the same laws which I employed as a dramatist.*

The most basic of all ideas was that of a search for the true significance of the man's apparently meaningless dying words. Kane was raised without a family. He was snatched from his mother's arms in early childhood. His parents were a bank. From the point of view of the psychologist, my character had never made what is known as 'transference' from his mother. Hence his failure with his wives. In making this clear in the course of the picture, it was my intent to lead the thoughts of my audience closer and closer to the solution of the enigma of his dying words. These were 'Rosebud'. The device of the picture calls for a newspaperman (who didn't know Kane) to interview people who knew him very well. None had ever heard of 'Rosebud'. Actually, as it turns out, 'Rosebud' is the trade name of a cheap little sled on which Kane was playing on the day he was taken away from his home and his mother. In his subconscious it represented the simplicity, the comfort, above all the lack of responsibility in his home, and also it stood for his mother's love which Kane never lost.

In his waking hours, Kane had certainly forgotten the sled and the name which was painted on it. Case books of psychiatrists are full of these stories. It was important for me in the picture to tell the audience as effectively as possible what this really meant. Clearly it would be undramatic and disappointing if an arbitrary character in the story popped up with the information. The best solution was the sled itself. Now, how could this sled still exist since it was built in 1880? It was necessary that my character be a collector – the kind of man who never throws anything away. I wished to use as a symbol – at the conclusion of the picture – a great expanse of objects – thousands and thousands of things – one of which is 'Rosebud'. This field of inanimate theatrical properties I wished to represent the very dustheap of a man's life. I wished the camera to show beautiful things, ugly things and useless things, too – indeed everything which could stand for a public career and a private life. I wished objects of art, objects of sentiment, and just plain objects. There was no way for me to do this except to make my

character, as I have said, a collector, and to give him a great house in which to keep his collections. The house itself occurred to me as a literal translation in terms of drama of the expression 'ivory tower'. The protagonist of my 'failure story' must retreat from a democracy which his money fails to buy and his power fails to control. There are two retreats possible: *death* and the *womb*. The house was the womb. Here too was all the grandeur, all the despotism which my man had found lacking in the outside world. Such was his estate – such was the obvious repository for a collection large enough to include, without straining the credulity of the audience – a little toy from the dead past of a great man.

Reprinted from Frank Brady, *Citizen Welles. A Biography of Orson Welles* (New York: Charles Scribner's Sons, 1989).

NOTES

1 Ronald Gottesman (ed.), *Focus on 'Citizen Kane'* (New Jersey: Prentice Hall, 1971).
2 Robert Carringer, *The Making of Citizen Kane* (London: John Murray, 1985).
3 *Persistence of Vision*, no. 7, 1989.
4 James Naremore, *The Magic World of Orson Welles* (New York: Oxford University Press, 1978).
5 Pauline Kael, *The Citizen Kane Book* (London: Secker & Warburg, 1971).
6 Peter Bogdanovich, 'The Kane Mutiny', *Esquire*, October 1972.
7 Gottesman, op. cit.
8 Patrick Ogle, 'Technological and Aesthetic Influences on the Development of Deep Focus Cinematography in the United States', in Bill Nicholls (ed.), *Movies and Methods* (Berkeley: University of California Press, 1985).
9 Barry Salt, *Film Style and Technology* (London: Starword, 1983).
10 Bernard Herrmann, 'Score for a Film', in Gottesman, *Focus on Citizen Kane*, p. 70.
11 Miriam Hansen, *Babel and Babylon* (Cambridge, Mass.: Harvard University Press, 1991), p. 191.
12 Quoted in Dudley Andrew, *André Bazin* (New York: Columbia University Press, 1990), p. 128.
13 Noel Carroll, 'Interpreting *Citizen Kane*', *Persistence of Vision*, no. 7, 1989, pp. 57–8.
14 However, Beverle Houston's article 'Power and Disintegration in the Films of Orson Welles', *Film Quarterly*, Summer 1982, brings a thought-provoking line of argument to bear on Kane's psychology and makes useful connections across other characters played by Welles in his films.
15 Carringer, op. cit., p. 11. Naremore, op. cit., and Frank Brady, *Citizen Welles* (New York: Charles Scribner's Sons, 1989) also give a full account of this experiment.
16 John Houseman, *Unfinished Business* (London: Chatto and Windus, 1986), p. 223.
17 Gottesman, op. cit.
18 See Michael Denning, 'Towards a People's Theatre: the Cultural Politics of the Mercury Theatre', *Persistence of Vision*, no. 7, 1989.
19 Houseman, op. cit., p. 87.
20 William Stott, *Documentary Expression in America* (London: Oxford University Press, 1973), p. 79.
21 W. A. Swanberg, *Citizen Hearst* (London: Longman, 1965), p. 477.
22 Kael, op. cit., p. 58.
23 Ogle, op. cit., p. 51.
24 Kael, op. cit., pp. 317–21. RKO Cutting Continuity of the Orson Welles Production *Citizen Kane*, hereafter referred to as CC.
25 Kael, op. cit., p. 408, CC.
26 Kael, op. cit., pp. 373–4,CC.
27 Kael, op. cit., pp. 374–5, CC.
28 Kael, op. cit., p. 340, CC.
29 See Paul Arthur, 'Orson Welles from Beginning to End: Every Film an Epitaph', in *Persistence of Vision*, no. 7, 1989.
30 Kael, op. cit., p. 328, CC.
31 Kael, op. cit., p. 340, CC.
32 Kael, op. cit., p. 332, CC.
33 Kael, op. cit., pp. 333–4, CC.
34 Swanberg, op. cit., p. 45.
35 Swanberg, op. cit., Book Three, 3.I.
36 Kael, op. cit., pp. 184–7. The Shooting Script, hereafter referred to as SS.
37 Kael, op. cit., pp. 363–4, CC.
38 Kael, op. cit., p. 230, SS.
39 Kael, op. cit., p. 387, CC.
40 Kael, op. cit., p. 338, CC.
41 Kael, op. cit., p. 355, CC.
42 Kael, op. cit., p. 178, SS.
43 Kael, op. cit., p. 361, CC.
44 Kael, op. cit., p. 340, CC.
45 Brady, op. cit., p. 85.
46 Introduction to Marion Davies, *The Times We Had* (New York: Bobs Merrill, 1975).
47 Houseman, op. cit., p. 229.
48 Sigmund Freud, 'Fetishism', *Standard Edition Vol. XXI* (London: Hogarth Press, 1961).
49 Carringer, op. cit., p. 54.
50 Kael, op. cit., pp. 348–9, CC.

CREDITS

· ·

Citizen Kane

USA
1941
Production company
A Mercury Production
Distributor
RKO Radio Pictures Inc.
Producer
Orson Welles
Associate producer
Richard Baer
Assistant producers
William Alland, Richard Wilson
Director
Orson Welles
Assistant directors
Eddie Donahoe, Fred A. Fleck
Screenplay
Herman J. Mankiewicz, Orson Welles
Photography (black and white)
Gregg Toland
Camera operator
Bert Shipman
Assistant cameraman
Eddie Garvin
Camera for early make-up and wardrobe tests
Russell Metty
Retakes and additional shooting
Harry J. Wild
Gaffer
William J. McClellan
Grip
Ralph Hoge
Music composed and conducted by
Bernard Herrmann
'Charlie Kane' lyrics
Herman Ruby
Dance choreographer
Arthur Appel
Editor
Robert Wise

Continuity
Amalia Kent
Assistant editor
Mark Robson
Art direction
Van Nest Polglase
Associate art director
Perry Ferguson
Assistant art director
Hilyard M. Brown
Principal sketch artist
Charles Ohmann
Sketches and graphics
Al Abbott, Claude Gillingwater Jr, Albert Pyke, Maurice Zuberano
Set decorator
Darrell Silvera
Assistant set decorator
Al Fields
Costumes
Edward Stevenson
Wardrobe
Earl Leas, Margaret Van Horn
Make-up
Maurice Seiderman
Assistant make-up
Layne Britton
Head of make-up department
Mel Berns
Special effects
Vernon L. Walker
Montage effects
Douglas Travers
Matte artist
Mario Larriaga
Effects camera
Russell Cully
Optical printing
Linwood G. Dunn
Sound recording
Bailey Fesler, James G. Stewart
Head of sound department
John Aalberg

Sound effects
Harry Essman
Boom operator
Jimmy Thompson
Stills
Alexander Kahle
Props
Charles Sayers
Publicity for Mercury Theatre
Herbert Drake
General press representative
Barret McCormick
119 minutes
10,800 feet

Joseph Cotten
Jedediah Leland/newsreel journalist
Dorothy Comingore
Susan Alexander Kane
Singing voice dubbed by
Jean Forward
Agnes Moorehead
Mary Kane
Ruth Warrick
Emily Norton Kane
Ray Collins
Jim 'Boss' W. Gettys
Erskine Sanford
Herbert Carter/newsreel journalist
Everett Sloane
Mr Bernstein
William Alland
Jerry Thompson/narrator
Paul Stewart
Raymond
George Coulouris
Walter Parks Thatcher
Fortunio Bonanova
Matiste
Gus Schilling
John, head waiter at 'El Rancho'/newsreel journalist

Philip Van Zandt
Mr Rawlston
Georgia Backus
Bertha Anderson
Harry Shannon
James Kane
Sonny Bupp
Kane III
Buddy Swan
Kane, aged eight
Orson Welles
Charles Foster Kane
Al Eben
Solly
Ellen Lowe
Miss Townsend
Charles Bennett
Entertainer
Irving Mitchell
Dr Corey
Joe Manz
Jennings
Alan Ladd, Harriet Brandon, Jack Santoro, Louise Currie, Eddie Coke, Walter Sande, Arthur O'Connell, Richard Wilson, Katherine Trosper, Milt Kibbee, Louis Natheaux
Reporters
Bruce Sidney
Newsman
Lew Harvey
Newspaperman
Tom Curran
Teddy Roosevelt
Ed Peil, Charles Meakin
Civic leaders
Mitchell Ingraham, Francis Sayles
Politicians
Louise Franklin
Maid
Edith Evanson
Nurse

Arthur Kay
Orchestra leader
Tudor Williams
Chorus master
James Mack
Prompter
Gohr Van Vleck, Jack Raymond
Stagehands
Herbert Corthell
City editor, Chicago Enquirer
Shimen Ruskin, George Sherwood, Eddie Cobb
Hirelings
Olin Francis
Expressman
Frances Neal
Ethel
Robert Dudley
Photographer
Tim Davis, George Noisom
Copy boys
Jack Curtis
Chief printer
Landers Stevens
Investigator
John Dilson, Walter James
Ward heelers
Joe North, William O'Brien
Thatcher's secretaries
Donna Dax
Housemaid
Myrtle Rischell
Governess
Petra De Silva
Newswoman
Gino Corrado
Gino, waiter at 'El Rancho'
Suzanne Dulier
Marie, French maid
Major McBride
Shadowgraph man

Karl Thomas
Jetsam
Glen Turnbull
Flotsam
Harry J. Vejar
Portuguese labourer
Captain Garcia
General
Art Yeoman
Speaker at Union Square
Phillip Morris
Politician
Edward Hemmer, Carmen La Roux, Marie Day
Bits
Albert Frazier
Gorilla man
Guy Repp, Buck Mack
Men
Jack Morton
Butler

The print of *Citizen Kane* in the National Film Archive derives from material acquired from the International Federation of Film Archives. Presentation of this film has been made possible by a grant from Eddie Kulukundis.
(Credits checked by Markku Salmi)

BIBLIOGRAPHY

André Bazin, *Orson Welles: A Critical View* (New York: Harper and Row, 1979).

Maurice Bessy, *Orson Welles. An Investigation into His Films and Philosophy* (New York: Crown Publishers, 1971).

Peter Bogdanovich, 'The Kane Mutiny', *Esquire*, 1972.

David Bordwell, '*Citizen Kane*', in Bill Nichols (ed.), *Movies and Methods* (Berkeley: University of California Press, 1976).

Frank Brady, *Citizen Welles. A Biography of Orson Welles* (New York: Charles Scribner's Sons, 1989).

Robert Carringer, *The Making of Citizen Kane* (London: John Murray, 1985).

Film Reader I, 1975. Special issue on *Citizen Kane*.

Sigmund Freud, 'On Creative Writing and Day Dreaming', *Standard Edition Vol. IX* (London: Hogarth Press, 1961).

Sigmund Freud, 'Fetishism', *Standard Edition Vol. XXI* (London: Hogarth Press, 1961).

Ronald Gottesman (ed.), *Focus on Citizen Kane* (New York: Prentice Hall, 1971).

John Houseman, *Unfinished Business* (London: Chatto and Windus, 1986).

Beverle Houston, 'Power and Disintegration in the Films of Orson Welles', *Film Quarterly*, Summer, 1982.

Sandra Joxe, *Citizen Kane Orson Welles* (Paris: Hatier, 1990).

Pauline Kael, *The Citizen Kane Book* (London: Secker and Warburg, 1971).

Joseph McBride, *Orson Welles* (London: Secker and Warburg/BFI, 1972).

James Naremore, *The Magic World of Orson Welles* (New York: Oxford University Press, 1978).

Patrick Ogle, 'The Aesthetic and Technological Influences on the Development of Deep Focus Cinematography in the United States', in Bill Nichols (ed.), *Movies and Methods* (Berkeley: University of California Press, 1986).

Persistence of Vision no. 7, 1989.

Barry Salt, *Film Style and Technology* (London: Starword, 1985).

William Stott, *Documentary Expression in America* (London: Oxford University Press, 1983).

W.A. Swanberg, *Citizen Hearst* (London: Longman, 1985).

Frank Tomasulo, 'Narrate *and* Describe? Point of view and voice in *Citizen Kane*'s Thatcher sequence', *Wide Angle*, vol 8, no 3–4, 1986.

Orson Welles, 'Introduction' to Marion Davies, *The Times We Had* (New York: Bobs Merrill, 1975).

Peter Wollen, '*Citizen Kane*', *Readings and Writings* (London: Verso, 1982).

Bret Wood, *Orson Welles. A Bio-Bibliography* (Westport, Conn.: Greenwood Press, 1990).

ALSO PUBLISHED

If you would like further information about future BFI Film Classics or about other books on film, media and popular culture from BFI Publishing, please write to:

BFI Film Classics
BFI Publishing
21 Stephen Street
London W1P 2LN

BFI FILM
CLASSICS

THE LIFE AND DEATH
OF COLONEL BLIMP

.....................

A. L. Kennedy

"Film Classics - *one of the best ideas BFI Publishing has had"*
SUNDAY TIMES

THE BIG SLEEP

......................

David Thomson

GUN CRAZY

Jim Kitses

"learned, well argued and passionate"
SIGHT AND SOUND

LES ENFANTS DU PARADIS

·····················

Jill Forbes

BFI FILM CLASSICS

BRIDE OF FRANKENSTEIN

· · · · · · · · · · · · · · · · · · ·

Alberto Manguel

THE WIZARD OF OZ

.

Salman Rushdie

*"Witty and vivacious ... shrewd and joyous ...
it adds to the movie's wonder, which is saying a lot"*
NEW STATESMAN

NICOLET HIGH SCHOOL
6701 N. Jean Nicolet Rd.
Glendale, WI 53217

DATE DUE

10/30	

DEMCO, INC. 38-2931